PLACING MEMORY: A PHOTOGRAPHIC EXPLORATION OF JAPANESE AMERICAN INTERNMENT

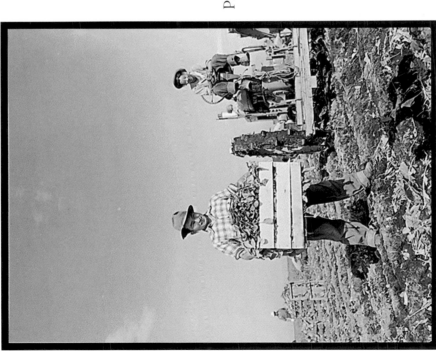

The Charles M. Russell Center Series on Art and Photography of the American West

B. Byron Price, General Editor

UNIVERSITY OF OKLAHOMA PRESS : NORMAN

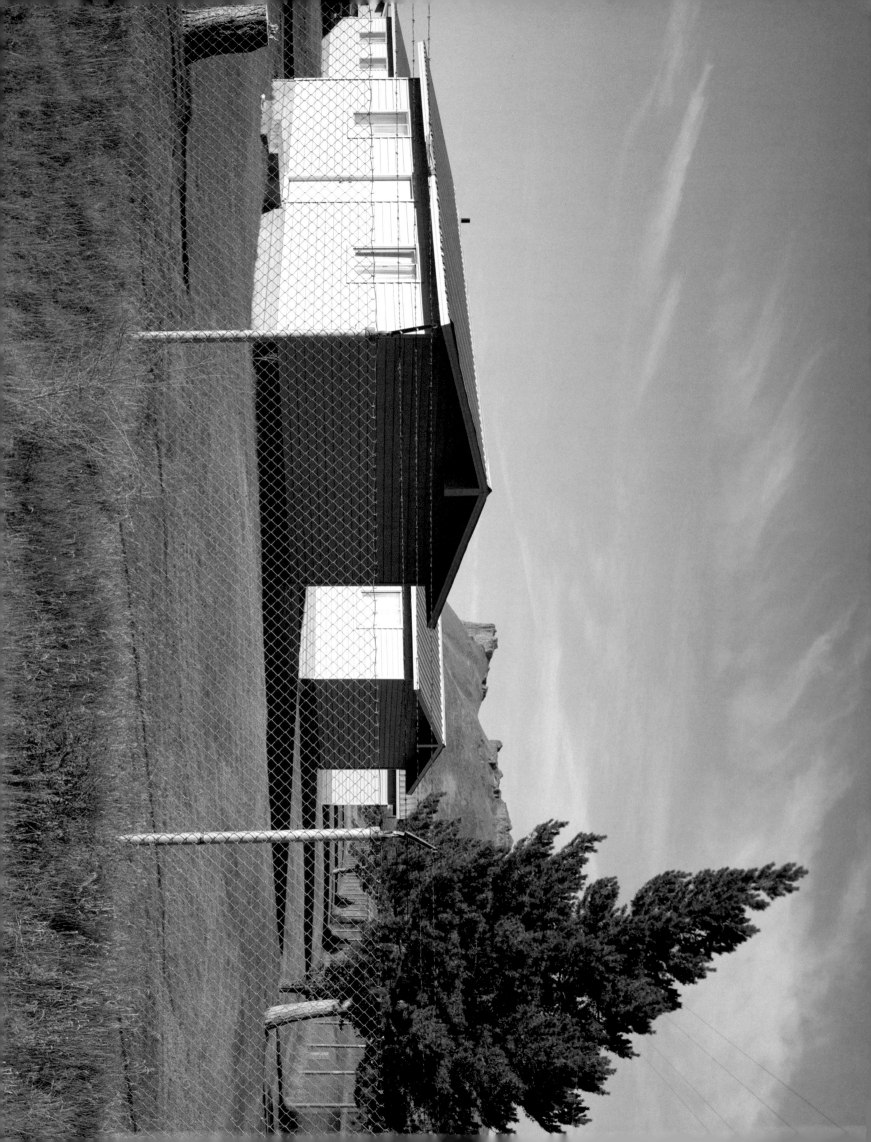

PLACING MEMORY

A PHOTOGRAPHIC EXPLORATION OF JAPANESE AMERICAN INTERNMENT

TODD STEWART

Essays by Natasha Egan and Karen J. Leong

Afterword by John Tateishi

Library of Congress Cataloging-in-Publication Data

Stewart, Todd, 1963–

Placing memory : a photographic exploration of
Japanese American internment / Todd Stewart ; essays
by Natasha Egan and Karen J. Leong ; afterword by
John Tateishi.

p. cm. – (The Charles M. Russell Center series on
art and photography of the American West ; v. 3)
Includes bibliographical references and index.

ISBN 978-0-8061-3951-7 (hbk. : alk. paper)

1. Japanese Americans – Evacuation and relocation,
1942–1945.
2. Japanese Americans – Evacuation and relocation,
1942–1945 – Pictorial works.
3. World War, 1939–1945 – Concentration camps –
United States.
4. World War, 1939–1945 – Concentration camps –
United States – Pictorial works. I. Egan, Natasha.
II. Leong, Karen J., 1968– III. Title.

D769.8.A6S75 2008
940.53'1773–dc22

Placing Memory: A Photographic Exploration of Japanese American
Internment is Volume 3 in The Charles M. Russell Center
Series on Art and Photography of the American West.

Design: Eric H. Anderson and Karen Hayes-Thumann.
Maps: Cong Zhang

The paper in this book meets the guidelines for
permanence and durability of the Committee on
Production Guidelines for Book Longevity of the
Council on Library Resources, Inc. ∞

1 2 3 4 5 6 7 8 9 10

PAGE i:

TULE LAKE RELOCATION CENTER, NEWELL, CALIFORNIA.
Photographer, Francis Stewart. [NAIL Control Number:
NWDNS-210-G-D1981] (see page 54)

PAGE ii:

Detail of MODERN MIGRANT WORKER HOUSING,
TULE LAKE RELOCATION CENTER, 2001.
Photographer, Todd Stewart (see page 55)

CONTENTS

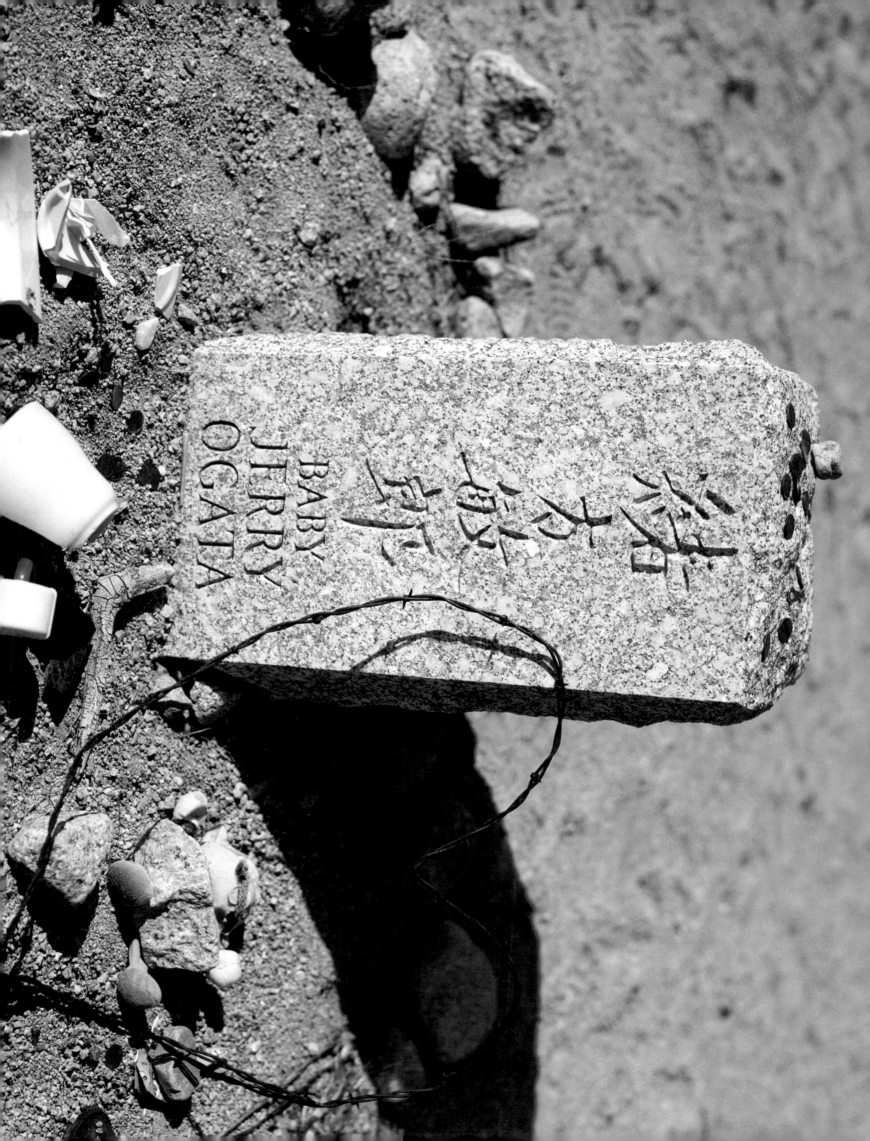

Todd Stewart

Introduction

On February 19, 1942, President Franklin D. Roosevelt signed Executive Order 9066 and thus initiated the largest single forced relocation in U.S. history. After Pearl Harbor, the U.S. government considered Japanese Americans living along the Pacific Coast to be national security risks. In response, persons of Japanese ancestry were forcibly removed from their homes and placed in one of ten relocation centers scattered throughout the country. Motivated by fear, politics, greed, and long-held racial prejudice, Americans were able to justify the confinement of nearly 120,000 Japanese Americans.

For many years my concerns as a photographer have centered on the relationships between history, myth, and culture. My work has included a growing exploration of the American landscape and a continued ex-

amination of the question: Does place hold memory? As part of this work, several years ago I began an extensive documentation of the ten Japanese American internment sites of World War II.

The first site I visited was the Manzanar Relocation Center near Independence, California. Although the only remaining major structure was the center's auditorium (then used to store highway construction equipment), camp roads, building foundations, garden remains, and other remnants from the site's history were still evident. What surprised me most about my visit to Manzanar was the immediacy of the experience. Although the landscape had been abandoned for fifty years, the presence of ten thousand internees was unmistakable.

Detail of CHILD'S GRAVE, CEMETERY, MANZANAR RELOCATION CENTER, 1999
Photograph by Todd Stewart (see page 35)

Robert Adams in his essay "Truth and Landscape" speaks of the three verities of landscape art—geography, autobiography, and metaphor. "Geography is, if taken alone," he writes, "sometimes boring, autobiography is frequently trivial, and metaphor can be dubious. But taken together, as in the best work of people like Alfred Stieglitz and Edward Weston, the three kinds of information strengthen each other and reinforce what we all work to keep intact—an affection for life."[1]

Adams's three verities are also of importance in the creation of my own work. As I make photographs in the landscape, I am first concerned that they be descriptive. I consider my work to be a survey of these sites, which implies a certain rigor in the presentation of information. My photographs represent an inventory of the physical features of each of these camps—roads, foundations, architectural remains, monuments, and so on. The structure of the survey is further reinforced by the inclusion of other descriptive materials such as maps, statistical information, and archival photographs.

Although a presentation of the physical details is important, I am still concerned that the work be, as Adams states, autobiographical and metaphorical. These descriptive photographs are intended to convey the formal fascination I found in the light, color, and texture of these places, as well as the silence and isolation I encountered at each of these sites. It may seem misguided to look for form and beauty in the evidence of such terrible events. But as the author Rebecca Solnit states in her essay "Scapeland," "Resisting evil often means resisting beauty; and many evils are tempting because of their aesthetics. To represent beauty may be to represent this tension between ethics and aesthetics, rather than to endorse that in which it appears; the condemnation of beautiful pictures of evil falls back on the old assumption that the beautiful should show up only as the good, that there shouldn't be any temptation we need to resist."[2]

The photograph is a complex cultural object. Because it is seemingly rooted in time and place, it traditionally has been endowed with a certain authority in regard to "truth." But truth is contingent. The black-and-white photographs included in this book are from the photographic file of the War Relocation Authority—the agency responsible for the administration of the camps. During the past sixty years, the "truth" of these photographs has shifted, as cultural attitudes regarding internment have changed and their value as historical documents has been complicated.

In this regard it is also important to consider the role of my own photographs. I realize these images are unable to convey the full complexity of the internment experience. That is a goal beyond my reach. Instead, I hope that this book might significantly contribute to the ongoing cultural discourse surrounding the

internment events. My emotional response to my first visit to Manzanar was what originally compelled me to undertake this project. As the work has progressed, my belief in the importance of the project has been reinforced. Recent events show the relevance of a contemporary examination of Japanese American internment and the need for a greater cultural understanding of the dangers of racial intolerance and injustice.

Notes

1. Robert Adams, Beauty in Photography: Essays in Defense of Traditional Values (New York: Aperture, 1981), 14.

2. Rebecca Solnit, "Scapeland," in Anne Wilkes Tucker, *Crimes and Splendors: The Desert Cantos of Richard Misrach* (Houston: Museum of Fine Arts, 1996), 47.

UNTITLED (OFF THE HIGHWAY) from the *Siberia* series, 2002
Photograph by Anna Shteynshleyger.
Courtesy the artist.

NORDLAGER OHRDRUF, 1995 from *War Story* (Munich, 1997)
Photograph by Mikael Levin. Courtesy the artist.

ROAD (detail from *Field, Road, Cloud*), 1997
Installation by Alfredo Jaar. Courtesy Galerie Lelong, New York.
© Alfredo Jaar.

Natasha Egan

Unearthing History

Todd Stewart offers a very specific landscape photography, one concerned with place, but only insofar as place relates to human history. His photographs can usefully be read in the broader context of a documentary photography that seeks to excavate politically charged historical events, now concealed by the seductive beauty of the landscapes that witnessed them. Consider the work of artists as diverse as Anna Shteynshleyger, Mikael Levin, and Alfredo Jaar, for comparison. Shteynshleyger's visually stunning photographs of the sites of Russian labor camps under the former Communist regime in Siberia depict places with a history of oppression, though they lack any discernable evidence. Levin's pictures of now desolate sites of World War II concentration camps in Germany and Poland give virtually no clues that atrocities once occurred there, other than subtle scars on the earth's surfaces. Jaar's conceptual installation *The Rwanda Project, 1994–1998* includes three beautiful pictures

taken in Rwanda of a field, a tree-lined road, and a lonely cloud in the blue sky, which seem to imply nature's dispassionate background to the horror of recent genocide.

In a similar vein, Stewart returns to now desolate sites where the U.S. government, over a period of nearly four years during World War II, interred over 110,000 immigrants of Japanese descent, two-thirds of them U.S. citizens. Formally sharing a grandeur style with earlier landscape photography, Stewart approaches his subject with an altogether different set of interests. In particular, what distinguishes his landscapes is not the natural beauty they convey or the capacity of nature to animate the human spirit but, rather, the history they bore witness to and that they now, to a certain degree, represent. Although historically grounded, this landscape photography aspires to do more than merely remind us of our history. Like classical landscape photography, it seeks a visceral or spiritual response.

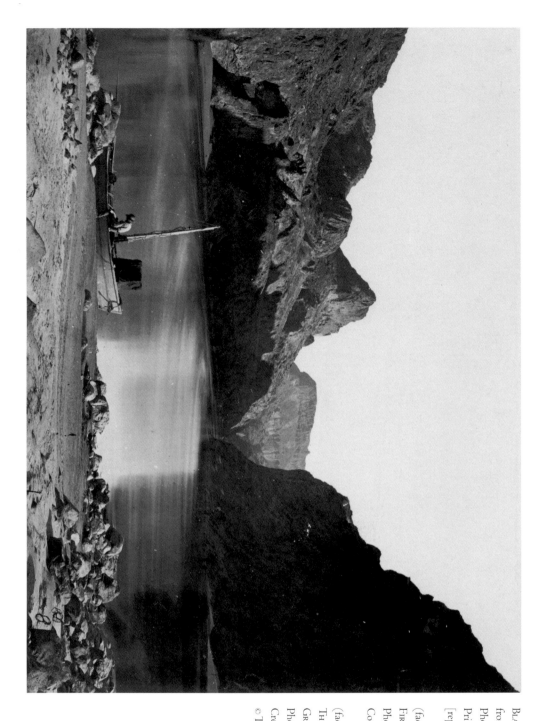

BLACK CAÑON COLORADO RIVER,
from camp 8, looking above, 1871.
Photograph by T. H. O'Sullivan, Library of Congress,
Prints & Photographs Division
[reproduction number: LC-DIG-PPMSCA-10017]

(facing page, above):
FIRST VIEW OF THE VALLEY, YOSEMITE, ca. 1865-66
Photograph by Carleton E. Watkins
Courtesy Fraenkel Gallery, San Francisco

(facing page, below):
THE TETONS AND THE SNAKE RIVER,
GRAND TETON NATIONAL PARK, WYOMING, 1942
Photograph by Ansel Adams. Collection Center for
Creative Photography, University of Arizona.
© The Ansel Adams Publishing Rights Trust

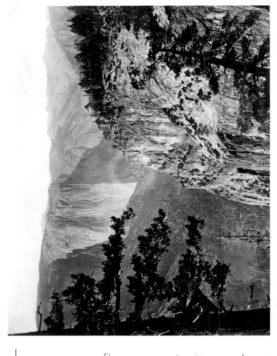 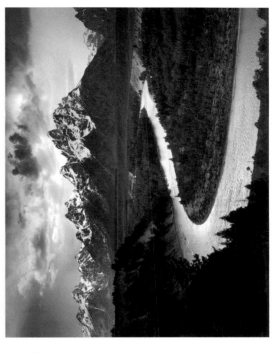

Origins of Landscape Photography

Landscape photography finds its origin in the middle of the nineteenth century, when photographers were strongly influenced by the Hudson River School of painting. Photographers such as William Henry Jackson, Timothy O'Sullivan, Carleton E. Watkins, and, a generation later, Edward Weston and Ansel Adams—made romantic images of the American West that emphasized the possibilities of human freedom inherent in those vast spaces. Like the painters, these landscape photographers were concerned above all with representing the *sublime* in nature, a notion articulated most famously perhaps by eighteenth-century political theorist Edmund Burke, who believed that a life of feeling and spirit depended on recognizing harmony within the larger order of the universe. Their images were designed to produce a mixture of awe, respect, morality, and enlightenment—to emphasize the power of God as reflected in his greatest creation, the natural world. Pictures were dramatically vast in scope, sometimes including a person dwarfed by the grand space, and printed with rich tonalities. The romantic notion of the sublime in the earlier work (that of Jackson, O'Sullivan, and Watkins, for example) was simply a style used by photographers hired to document the West. They were mixing technical reportage with effective pictorial conventions from painting. Later, in the work of Weston and Adams, natural beauty in the abstract became transcendent of both time and place.

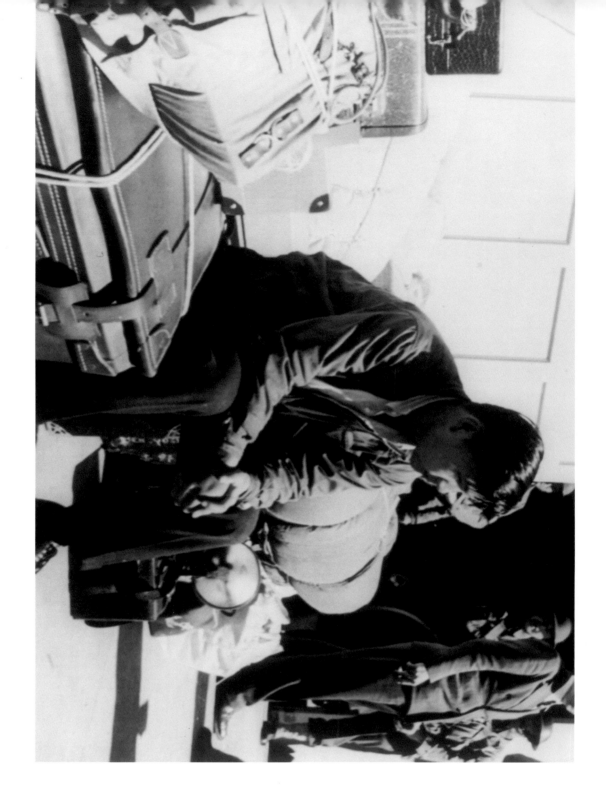

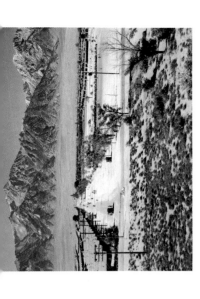

The Japanese American Relocation and Internment Camps

Stewart's landscapes, on the other hand, are all about time and place—specifically, the sites of the ten Japanese American internment and relocation camps hastily constructed in the spring of 1942 in less than hospitable areas of the American West. The camps were a byproduct of American security fears following the December 1941 Japanese attack on Pearl Harbor. They held nearly the entire Japanese community then living within fifty miles of the U.S. West Coast. There is a diversity of opinion among those interred concerning the justice of this wartime government policy. Some felt a patriotic duty to honor the government's demands, whereas others balked at the suspension of their constitutional rights and the adverse economic and emotional impact on many families.[2] No Japanese American was ever accused or convicted of espionage during World War II. However one may view this, it seems clear that suddenly living among seemingly endless rows of identical, temporary, tar paper–covered barracks

was trying, to say the least. Surrounded by dusty baseball fields, encircled by barbed-wire fences, dominated by guard towers, these were crowded quarters lacking privacy. Within the first few months of Manzanar, the largest camp, a riot broke out, which resulted in the shooting deaths of two internees by military police. There were also inordinate numbers of suicides among internees.[3] In general, however, the Japanese Americans sought to create peaceful communities within the fences. The same vast western spaces that had so inspired early landscape photographers now loomed beyond the fences, conjuring an entirely different set of emotions, among them isolation, fear, and bitterness.[4]

It is interesting to consider the various ways that these camps were represented by photographers at the time. In the fall of 1942, Ralph Merritt (an old climbing friend of Ansel Adams) had recently been appointed director of the Manzanar War Relocation Center. He invited Adams to document the camp and

its people, their daily life, and their relationship to their community and environment.[5]

The War Relocation Authority (WRA) had already hired numerous photographers to document the relocation process and the camps. Dorothea Lange, famous for her work with the Farm Security Administration, was one of those assigned to photograph the removal of internees from their homes. It is fair to say that, owing to censorship, the WRA pictures generally represent the official government view of internment. In the authorized camp images, for example, it was forbidden to show a fence, a guard, a guard tower, or guns. Instead, the images portrayed the internees leading quintessentially "American" lives—adults working, children at school, internees playing baseball or engaged in other leisure activities, and often smiling at the camera. In this way, the pictures clearly have a propagandist tendency. It is ironic that the government-authorized images (of which thirty-five are included here) portrayed the

MANZANAR FROM GUARD TOWER VIEW WEST, 1944
Photograph by Ansel Adams. Library of Congress, Prints & Photographs Division [reproduction number: LC-DIG-PPPRS-00275].

internees as mainstream Americans, even as they were deprived of the basic rights of American citizenship. Lange, on the other hand, successfully captured the gravity of the situation by juxtaposing signs of human courage and dignity against evidence of the indignities of life in the camps. It is not surprising that she found herself at odds with the WRA, which in fact censored many of her images.[6]

Adams's approach was altogether different. He used the camera to express his emotional response to the situation through metaphor. Taking an almost romantic view, he brought individualism and hope to the subject, while simultaneously leading his viewers to consider the realities of the internees' experiences. The work had the very intentional effect of humanizing the apparent enemy. It includes close-up portraits of children and women looking outward and smiling, and of men often looking directly into the camera with sincerity. He also stepped outside the camp and photographed the dramatic landscape beyond the barbed-

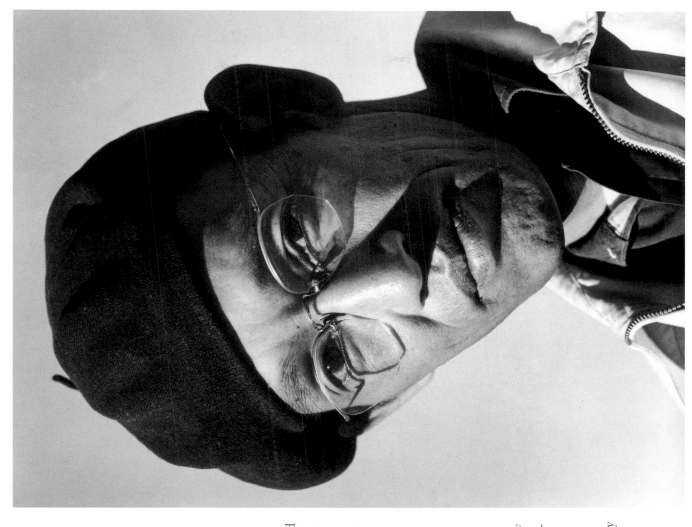

TOYO MIYATAKE, 1943
Photograph by Ansel Adams. Library of Congress, Prints &
Photographs Division [reproduction number: LC-DIG-PPPRS-00448]

wire fences. Adams's critical text and warm portraits of the internees—published in 1944 in the form of a book bearing the ironic and provocative title *Born Free and Equal*, and also exhibited at the Museum of Modern Art in New York—politicized the project. Although the book was approved by the WRA, its shrewd negotiation of the censors' rules, public prejudices, and controversy regarding the extent to which Adams's work served propagandist purposes resulted in a shift in attitude at MOMA. Certain texts and images were omitted from the exhibition, and the title of the exhibition was changed simply to *Manzanar*. Because of wartime-fueled racism, both the exhibition and the publication *Born Free and Equal* received mixed reviews, and the book fell into obscurity for nearly thirty years because of poor production and distribution.[7]

Since internees were forbidden to bring cameras into the camps, there are unfortunately few views of the camps from an insider perspective. Photographer Toyo Miyatake, forced

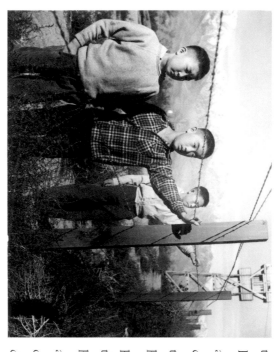

to leave his home and photography studio in Los Angeles, took the risk of smuggling a lens and film into Manzanar. Using a camera body constructed from scraps of wood, he clandestinely recorded camp life. Three months into his stay at Manzanar he told his son: "As a photographer, I have a responsibility to record the camp life so this kind of thing will never happen again."[8] He was caught, but he was able to convince Merritt of the importance of recording graduations, births, and weddings in the Manzanar community, which had become the largest community between Los Angeles and Reno. Merritt eventually gave Miyatake clearance to photograph without supervision. Although not published until after the camps closed, the picture that was used the most frequently to symbolize the injustice of the incarceration of Japanese Americans during the war is the poignant image taken by Miyatake, alternately entitled *Boys Behind Barbed Wire* or *Norito Takamoto, Bruce Sansui, and*

Masaaki Imamura. Three boys stand in the desert brush behind a barbed-wire fence, which has the effect of emphasizing their defenselessness. During the waning years of the war, the military presence at Manzanar was diminished, which allowed internees to explore the Sierras with limited freedom. This may explain why the boys in Miyatake's photograph are in fact on the outside of the fence, not looking reflectively into a vast landscape but, rather, looking back toward the camp, as if to suggest the effect of this experience on their future lives.[9]

After the bombing of Hiroshima and Nagasaki in August 1945 (another source of tragedy for the internees), the war came to an end, and the camps began to close. Most of them closed as early as October and November 1945. The last one to close, in March 1946, was Tule Lake in California, to which were sent detainees who would not take a loyalty oath to the United States. Some internees were fortunate enough to return to their

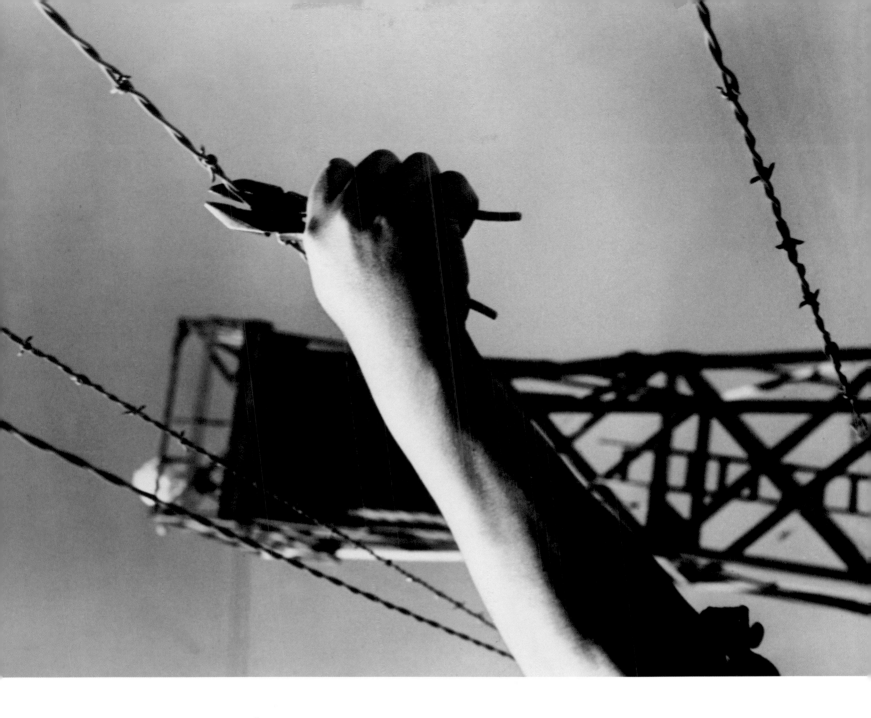

CUTTING BARBED WIRE, 1945
Photograph by Toyo Miyatake
©Toyo Miyatake Studio, San
Gabriel, California

BROKEN TREES, NEAR BOX SPRINGS MOUNTAINS, EAST OF RIVERSIDE, CALIFORNIA, 1982
Photograph by Robert Adams Courtesy Fraenkel Gallery, San Francisco

WILLOW AND SIERRA NEVADAS, MANZANAR RELOCATION CENTER, 1999
Photograph by Todd Stewart (see page 42)

homes and start back up where they had left off. Most of them, however, faced heightened racism on the West Coast. Some moved to the Midwest or the East Coast. The rest learned to cope with ongoing racial intolerance. After the camps were entirely evacuated, many of the buildings were torn down, relocated to communities nearby, or sold to GIs for temporary housing. In 1980 the Presidential Commission on Wartime Relocation and Internment of Civilians wrote that "a nation which wishes to remain just to its citizens must not forget its lapses."[10] Nine years later, President George H. W. Bush signed legislation to pay twenty thousand dollars to each internee for his or her loss of property and freedom. The money came with a formal apology also. In the arid climate of the western desert, however, remnants left behind could take a very long time before they disappeared completely. Until then, they serve as a monument to this history.

When all the occupants of Manzanar have resumed their places in the stream of American life, these flimsy buildings will vanish, the greens and flowers brought in to make life more understandable will wither, the old orchards will grow older, remnants of paths, foundations and terracing will gradually blend unto the stable texture desert. The stone shells of the gateway and the shaft of the cemetery monument will assume the dignity of desert ruins; the wind will move over the land and the snow fall upon it; the hot summer sun will nourish the gray sage and shimmer in the gullies. Yet we know that the human challenge of Manzanar will rise insistently all over America—and America cannot deny its tremendous implications.[11]

Sixty years after Ansel Adams wrote these prescient words, the camps have in fact nearly vanished; but Todd Stewart has now embarked on the task of unearthing the silent history of the ten western internment and relocation camps. Although, like Adams, he turns his lens on western vistas, Stewart's pictures are different. Adams made himself famous by creating dramatic tableaux in which pristine territory, stunning in its immensity, unfolded before the viewer's eye. Beautiful in their own way, Stewart's photographs are more reminiscent of landscapes taken by photographer and writer Robert Adams, who was interested not in a pristine nature but in a nature disrupted by human activity. Similarly, Stewart documents a place not because of its natural beauty—arguably the defining feature of classical landscape photography—but because of what has occurred there. The details he is concerned to highlight therefore include not only clouds and shadow but also disturbed earth, broken cement slabs, unconnected electric poles, concrete structures, and chimneys. These compositional elements suggest a narrative in a way that classical landscape photography does not, although the story remains obscure.

In Stewart's photograph entitled *Willow and Sierra Nevada*, taken at Manzanar, an over-grown bush grows out of a large shallow rect-angular hole centered in a vast desert. Gray sage and sow thistle, a weed that thrives in disturbed earth, extends as far as the eye can see. Behind the bush one can detect a sliver of an unused dirt road. In the foreground, depressions in the sand suggest that someone has recently walked near the tree. In the back-ground, the Sierra Nevada is illuminated in brilliant pink. Mount Williamson looms over fourteen thousand feet above the desert plain. Nothing in the image situates it historically. The inaccessibility of this place underscores the extent to which its history has eluded popular consciousness.

Although appropriating many of the formal techniques used by classical land-scape photographers such as large vistas and dramatic skies, Stewart manages to evoke an emotional response of a different order. Classical landscape photography works by eliciting notions of the sublime or of human inconsequence. Stewart's photographs work by bringing human history back into the landscape, thereby undermining what we're accustomed to look for in these pictures. In *Willow and Sierra Nevada* the unnatural rectan-gular-shaped hole in the earth reveals a prior human history. This history, it seems, was not entirely in accordance with nature, which rarely produces right angles. In other images, a tree, a slab of cement, or a guard station at the center of the photographic field obstructs one's view of an otherwise beautiful vista. Confining, understated, cluttered with hu-man facts, Stewart's pictures are not designed to invoke the sublime. He does not counte-nance the myth of the American West as an untouched land of unfettered potential. This is, after all, territory that was appropriated—more than a century before the Japanese camps—in the name of "Manifest Destiny," and at the expense of the indigenous popula-tion. Instead, as with Shteynshleyger's, Levin's, and Jaar's landscapes, romantic notions of the sublime are displaced by the forced recol-lection of a brutal human history. Stewart's landscapes do more than remind us of our history. They remind us of our humanity—or inhumanity, as the case may be.

NOTES

1. Edmund Burke, *A Philosophical Enquiry Into the Origin of Our Ideas of the Sublime and Beautiful* (London, 1757), in *Collected Works*, ed. T.W. Copeland (London: 1865-1867).

2. David Takami, *Executive Order 9066: Fifty Years before and Fifty Years After* (catalogue for exhibit of the same name, showing at the Wing Luke Asian Museum from February 19 to August 31, 1992), 32.

3. Direct communications to Rod Slemmons (then curator of photography, Seattle Art Museum) from Kay Nakao, internee and nurse at Manzanar, 1942-1944, during interviews for the exhibition *Kodomo No Tamenni*, produced by Slemmons for the Bainbridge Island, Washington, Japanese American Community, 1988-1991.

4. Ansel Adams, *Born Free and Equal* (U.S. Camera, 1944), 44-51.

5. Ansel Adams, with Mary Street Alinder, *Ansel Adams—An Autobiography* (New York: Graphic Society, Little Brown and Company, 1985), 260.

6. Gerald H. Robinson, *Elusive Truth: Four Photographers at Manzanar*, introduction by Archie Miyatake (Nevada City, Calif.: Carl Mautz, 2002), 16-18.

7. It was reviewed by Nancy Newhall, in *"Born Free and Equal, by Ansel Adams: Photographs of the Loyal Japanese Americans at Manzanar Relocation Center, Inyo County, California," Photo Notes* (Photo League, June 1946).

8. Robinson, *Elusive Truth*, 11.

9. Jasmine Alinder, "Toyo Miyatake's 'Boys Behind Barbed Wire': Photography in the History of Japanese American Internment," *Journal of the International Institute* (University of Michigan) 6, no. 1 (fall 1998).

10. U.S. Commission on Wartime Relocation and Internment of Civilians, *Personal Justice Denied: Report of the Commission on Wartime Relocation and Internment of Civilians*, foreword by Tesuden Kashima (Seattle: University of Washington Press and the Civil Liberties Public Education Fund, 1997), 463.

11. Adams, *Born Free and Equal*, 25, 29.

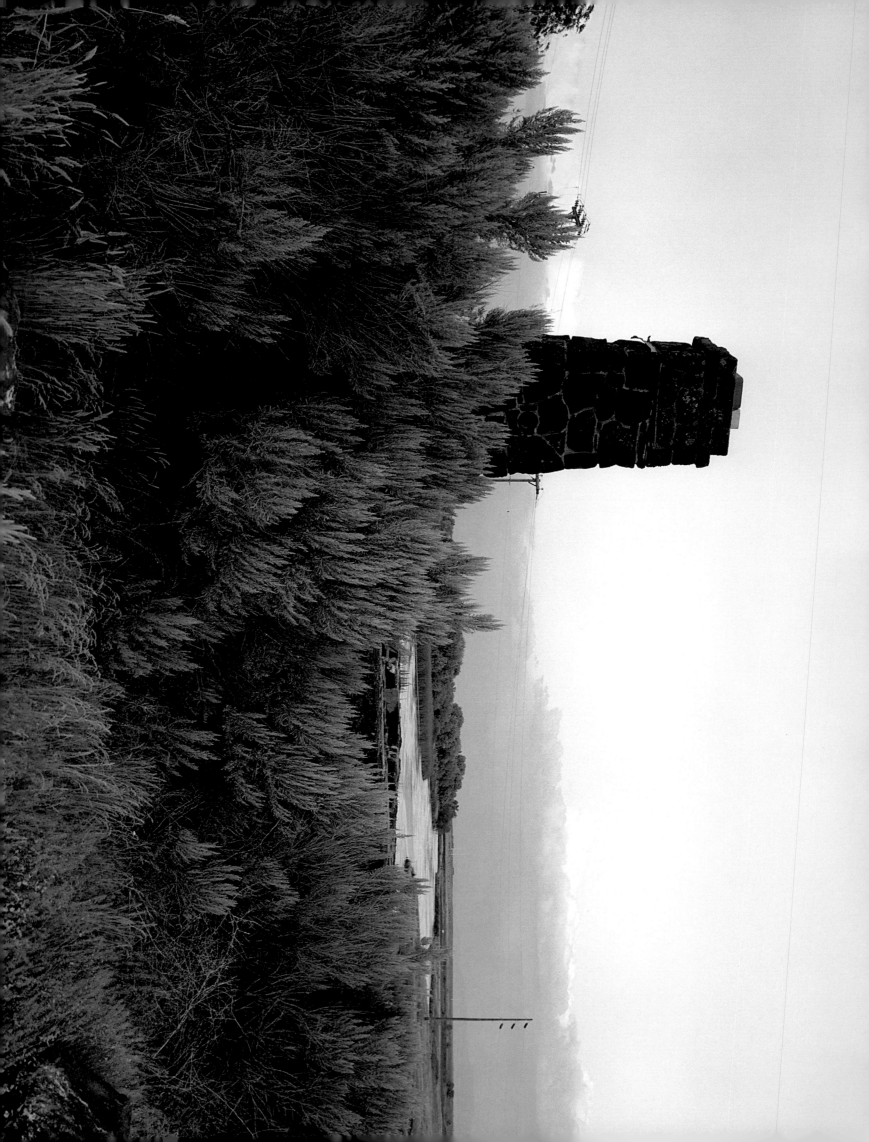

KAREN J. LEONG

ENVISIONING A USABLE PAST

Photographs of the Japanese American Internment as History, Memory, and Testimony

In 1946 the U.S. government closed the ten concentration camps run by the U.S. War Relocation Authority: Poston and Gila River in Arizona, Tule Lake and Manzanar in California, Topaz in Utah, Heart Mountain in Wyoming, Jerome and Rohwer in Arkansas, Minidoka in Idaho, and Amache in Colorado. For forty years, these camps and the history they represented were overlooked—abandoned sites of history. The history that defined these sites was not one of national pride but of national shame. It was not until the 1980s that third-generation Japanese Americans were able to voice what their parents and grandparents had struggled to keep silent for so long; the injustice of forced removal of U.S. citizens and the utter betrayal of their rights. Now, sixty years later, Todd Stewart reopens

this history and contrasts the official record as documented by government-employed photographers with his own contemporary meditations on the sites as they remain today.

The late scholar Gloria Anzaldúa in her autohistória, *Borderlands/La Frontera*, describes how natural borders are subjugated by man-made borders. Natural borders—such as the ocean and the shoreline—are fluid, always changing and adapting. Man-made borders, on the other hand, are inherently unnatural, a demonstration of power inflicted upon specific communities and their landscapes.[1] These relocation camp sites as documented by Todd Stewart remain as monuments to the man-made borders of prejudice and institutionalized racism that populated the U.S. landscape during World War II. Fragments

Detail of CHIMNEY, VISITORS' WAITING ROOM, MINIDOKA RELOCATION CENTER, 2000
Photograph by Todd Stewart (see page 69)

of barbed wire that litter the earth and the stone foundations of guard towers reflect the violence articulated in the construction of assembly centers, FBI prison camps, and WRA internment camps for nearly 120,000 individuals of Japanese ancestry. The decision to remove and confine Americans of Japanese descent (two-thirds of those interned) not only violated the rights of those interned, it also violated the U.S. Constitution and revealed that justice, freedom, and due process are not necessarily accessible to all citizens equally.

After the Japanese attacked Pearl Harbor on December 7, 1941, a day that would "live in infamy," the United States officially entered the war against the Axis powers of Germany, Italy, and Japan. The decision had long-reaching consequences for the immigrants from these three countries who were living in the United States, serving as leaders in their immigrant communities, often speaking the language of their homeland, and maintaining other cultural connections. The FBI removed the leaders of these ethnic communities from their homes and detained them as early as December 8, 1941. In the case of Japanese Americans, long-held resentments on the West Coast toward Asians as foreigners and economic competitors—evidenced in the 1882 and 1904 Chinese exclusion acts and later alien land laws enacted by various western states—were only further inflamed. Asian immigrants were not allowed to become naturalized U.S. citizens, yet some interpreted their lack of citizenship as reflecting their continued loyalty to Japan.

According to the report *Personal Justice Denied*, published by the U.S. Commission on Wartime Relocation and Internment of Civilians in 1982, there was little reason other than racial prejudice for the mass relocation and detention of Japanese Americans during the war.[2] Even though J. Edgar Hoover informed President Franklin Delano Roosevelt that the FBI had already removed and detained all persons considered suspicious, political pressures to remove all Japanese Americans from the West Coast intensified. The president signed Executive Order 9066 on February 19, 1942, which authorized the forced removal of "all persons of Japanese Ancestry" from designated "military areas." These designated military zones extended along the western coast from the Canadian border to the Mexican border. On March 11, General John L. DeWitt, commander of the Western Defense Command and Fourth Army created the Wartime Civil Control Agency (WCCA) to oversee the evacuation of Japanese Americans. On March 18, 1942, Roosevelt, by executive order, created

the War Relocation Authority (WRA), whose responsibility was to assist the evacuees and administer the ten relocation centers.[3]

Evacuation of persons from these zones began in April 1942, with individual families and entire communities first moved from their residences to assembly centers— rapidly constructed makeshift quarters. From there people were ordered onto trains and transported further east into remote, often desert, areas where the military had constructed what they at the time called "concentration camps." The WCCA was dissolved in March 1943, when this relocation of Japanese Americans to the internment camps was complete.

The WRA, however, was just beginning its work. The internment camps provided low-paid agricultural labor for nearby farmers, engineering expertise and labor to complete the Parker Dam in Arizona, and the production of parachutes and camouflage nets as well as technological innovations for the U.S. war industry. WRA officials also sought to facilitate relocation for several in-

dividuals and families by locating jobs such as domestic or factory work for internees throughout the Midwest. Furthermore, as several scholars including anthropologist Orin Starn and more recently Brian Hayashi have noted, the WRA was an experiment in social engineering, literally creating communities among individuals and families who, by virtue of their shared ancestry, were now living together in Idaho, Utah, Arizona, Arkansas, and other isolated locations.[4] As WRA officials— many who were highly educated and trained in social sciences—themselves noted at the time, thorough documentation would be valuable given the "serious implications" of this "precedent shattering and at the same time... precedent making" relocation program.[5]

Monuments to Humanity

Today, two decades after Japanese Americans successfully demanded both reparations and an apology for their forced evacuation and internment during World War II, beginning with President Franklin D. Roosevelt's Executive Order 9066, their internment has become more prominent in the national consciousness. After the terrorist attacks on September 11, 2001, for example, threats and actual violence against people who appeared to be of Middle Eastern ancestry provoked cautionary reminders of the Japanese American internment. What is often evoked during discussions is that "those who do not remember the past are condemned to repeat it." For some, the internment serves as a prominent example of how prejudice and fear can easily compromise democracy and freedom.

This perspective on the Japanese American internment can also be limiting, however. Internment itself was unconstitutional, traumatic, and wrong. The sites of the ten relocation centers serve also as monuments to the resiliency of those confined within the fences. The Japanese Americans involuntarily relocated to these remote sites, yet they created communities among themselves. Valerie Matsumoto has written about the renaissance of Japanese culture and arts that developed from the enforced confinement of first- and second-generation Japanese Americans." The remains of the camps located on the Gila River Indian Reservation in Arizona show the creativity of internees. In order to cool their homes, they built fish ponds beneath the barracks with concrete, rocks, and bits of glass and metal salvaged from bottles and cans. Just as the Issei built homes, temples, and churches for their communities, the internees likewise applied their skills to transforming the stark generic barracks into personalized spaces. Written into the concrete are initials, Japanese characters, and dates. This too is universal—the act of claiming one's identity is a form of resistance to oppression. Here it is resistance specifically to the dehumanization of internment.

The sites memorialized in photography here are also monuments to interactions that transcended the barbed wire. The camp perimeter was porous, permeated by the best human impulses. The Kabuki Theater at Poston in Parker, Arizona (also on American Indian land, in this case the Colorado River Indian Tribes Reservation), likewise was the handiwork of the internees. The silks and traditional costumes used in the Kabuki performances were provided by visitors or sent by post to those in the camps. In Arizona, some of the Akimel O'otham at Gila River and the Mohave at Parker interacted with the Japanese Americans in the camps. Some Euro-Americans who disagreed with the U.S. government's policy of internment started the Nisei Relocation Fund, working together through various educational and faith-based organizations to help Japanese American college students continue their education east of the military zones and not be interned. This movement eventually gave birth to the National Japanese American Student Relocation

Council, which raised funds to sponsor second-generation Japanese Americans to leave the camps and attend college in the eastern part of the United States. Japanese American families still recall the friends and neighbors who visited, sent items and letters, and provided encouragement during those years.

Many of the sites serve also as memorials to the sacrifices of Japanese American families whose sons and brothers joined the U.S. armed forces. Some were interpreters for the Military Intelligence Service. Many more were members of the segregated, all-Japanese unit, the 442nd battalion. Although much has been written about the heroics of the 442nd on the European front, and more remains to be written about the significant contributions and sacrifices of the Nisei men who provided vital translation services to the U.S. government, it cannot be overemphasized that these men were fighting also for the recognition that they were indeed U.S. citizens. Many of the former internment camp sites contain memorials to the men who lost their lives

fighting dual fronts—the war against U.S. fear and prejudice on the one hand, and the war for democracy against the Axis powers on the other. The memorials serve a dual purpose—to remember the names of those who sacrificed their lives for their country, and to remember the first-generation Japanese immigrants who built these memorials to their sons, and who were denied the opportunity to become naturalized U.S. citizens.

The photographs of Todd Stewart represent a return to this story, a dialogue with our collective memory of this event, to recall these overlapping and sometimes contradictory histories. They provide a documentation of the internment as a usable past, confronting our collective memory of this event, challenging the borders we create based on prejudice and fear, and reminding us that the United States has been, and still remains, a democracy in process.

PHOTOGRAPHIC MEMORIES

One of the methods of documentation was photography. During the 1930s photography had emerged as an important tool of documentation. The Farm Security Administration (FSA), for example, used photographs to publicize its work, and Dorothea Lange produced her famous image of the "Migrant Mother" as part of the FSA's public relations efforts. Public response to photographs often equated photography with "reality," even though, in the case of Lange's photograph, subjects could easily be posed for effect.[6]

The WRA hired a staff of photographers, of whom several had worked with the FSA. These photographers, including Lange, Francis Stewart, and others, were assigned at first to document the evacuation of Japanese Americans and their relocation to the assembly centers (many of them in California) and then to specific internment camps. The photographs themselves thus serve as memorials, documents significant to a community's history. Indeed, the impact of dispossession and forced evacuation is written starkly upon the face of the elderly Issei (immigrant generation) woman standing by the train, alone. The innocent face of a child sitting upon a bag of her family's belongings eating an apple has reminded audiences that even children, most of them U.S. citizens, were suspect because of their national heritage. As Anita Haya Patterson notes in her discussion of World War II artistic productions, widely circulated photos were of well-dressed Japanese American families smiling as they exited the trains. Oral histories suggest that these smiles may have been smiles of fear or intense relief—at least one interviewee indicated that evacuees on his train had no idea where they were going. They had heard rumors they were to be taken to the desert and killed.[7]

As the WRA's role changed from administering the internment camps to placing Japanese Americans in the midwestern and eastern regions of the United States, the agency's use of photographs likewise shifted. Initially during the evacuation to the assembly centers, the WCCA and the WRA censored some of the photographs taken by its photographers for fear that the images of families in hastily converted horse barracks might arouse sympathy for the internees. Frank C. Cross, chief of the WRA's Division of Reports, in 1942 noted in a confidential memorandum:

Any campaign to arouse sympathy for Japanese evacuees at the present time, however, might be dangerous, inasmuch that it would almost inavoidably [sic] arouse the rancor of certain elements of our population. Moreover, it would raise the question of why the evacuation was necessary. In other words, if the great percentage of Japanese are loyal citizens, then why were they not permitted to remain where they were living? ... Any statement that may be misinterpreted to indicate that the evacuees are receiving harsh treatment, that they are subject to unnecessarily stern restrictions, or forced to live under unfavorable conditions should also be strictly censored, not only to protect our own organization but to avoid providing material which might be used to advantage by Axis propagandists.[8]

By 1945, however, the WRA began seeking to reintroduce internees to "American society." Having successfully persuaded many Americans that Japanese Americans were a threat to national security, the U.S. government now faced the daunting task of convincing employers and landlords to hire and rent to former internees. The agency released a pamphlet advertising the skills and capabilities of Japanese Americans and featuring photos of smiling Japanese Americans doing clerical, agricultural, and mechanical work. The agency began to emphasize that Japanese Americans were loyal citizens and deserved opportunities for work. Yet the stigma of being foreign, and the nation's collective desire to forget the internment, contributed to the absence of internment from U.S. historical memory for decades.[9]

The photographic record of the Japanese American internment is significant for many reasons. The entire WRA photograph collection documents the impact of internment on individuals, families, and community.

It provides limited glimpses of individuals' different responses to internment, from social events and the personalization of living quarters to schooling and work. Certain photographers were censored more than others. Dorothea Lange and Clem Albers, for example, saw several of their photographs censored—particularly those depicting the reality of armed guards supervising the evacuees.[10] Others such as Francis Stewart chose to depict the evacuees as everyday Americans engaged in ordinary daily activities such as eating dinner together or reading popular magazines. Both perspectives are to some extent true. Yet, as with any historical event or artifact, it is important to remember that these commissioned photographs were first framed by the photographers composing the shots, then edited and selected by WRA and army officials for specific purposes and for viewers of diverse backgrounds subsequently to interpret what they witnessed according to their own experiences and perspectives.

A photographic image constitutes a window into a particular fixed moment in time. Read within their specific social and historical contexts, some of the images in this book may display vivid details of everyday life—from the perspective of those who smuggled cameras into the camps, for example. Photographs produced within the context of official state narratives, on the other hand, may be read as articulations of government policies—particularly when comparing censored photographs to those featured in mass-produced publications. Of the latter, those photographs that then became the iconic images of events further attest to the power of collective memory that helps define a national identity and consciousness. The individual photographer, moreover, is influenced by cultural discourse, which shapes his or her framing and presentation of the subject matter, just as contemporary cultural discourse shapes the viewers' interpretations. These dynamics are made visible in this book.

Notes

1. Gloria Anzaldúa, "The Homeland, Aztlán/ El Otro México," chap. 1 in *Borderlands/La Frontera: The New Mestiza*, 2nd ed. (San Francisco, Calif.: Aunt Lute Books, 1999), 23–36.

2. *Personal Justice Denied: Report of the Commission on Wartime Relocation and Internment of Civilians* (Washington, D.C.: Government Printing Office, 1982).

3. Greg Robinson, in *By Order of the President: FDR and the Internment of Japanese Americans* (Cambridge, Mass.: Boston University Press, 2001), details President Franklin D. Roosevelt's role in the internment.

4. Orin Starn, "Engineering Internment: Anthropologists and the War Relocation Authority," *American Ethnologist* 13, no. 4 (November 1986): 700–720; Brian Hayashi, *Democratizing the Enemy* (Princeton, N.J.: Princeton University Press), 2004. Greg Robinson, *By Order of the President: FDR and the Internment of Japanese Americans* (Cambridge, Mass.: Boston University Press, 2003).

5. "Documentation Program of the War Relocation Authority," Japanese American War Relocation file, Bancroft Library, University of California, Berkeley, October 12, 1942, 13.

6. Lawrence W. Levine, "The Historian and the Icon: Photography and the History of the American People in the 1930s and 1940s," and Alan Trachtenberg, "From Image to Story: Reading the File," both in *Documenting America 1935–1943 (Approaches to American Culture)*, ed. Carl Fleischhauer and Beverly W. Brannan (Berkeley and Los Angeles: University of California Press, 1988), 15–75.

7. Anita Haya Patterson, "Resistance to Images of the Internment: Mitsuye Yamada's *Camp Notes*," *MELUS* 23, no. 3 (autumn 1998): 103–27. Oral histories from Japanese Americans in Arizona Oral History Project, Asian Pacific American Studies Program, Arizona State University, Tempe, Arizona.

8. Frank C. Cross, Chief Division of Reports, *Confidential Memorandum re: "Preview of the Division of Reports—Its Functions and Services"* (Japanese American War Relocation File, Bancroft Library, University of California, Berkeley, California), July 21, 1942, 5.

9. Caroline Chung Simpson, *An Absent Presence: Japanese Americans in Postwar American Culture, 1945–1960* (Durham, N.C.: Duke University Press, 2001).

10. Since this essay was written, a new book has come out about Lange's censored photos. See Dorothea Lange, *Impounded: Dorothea Lange and the Censored Images of Japanese American Internment*, ed. Linda Gordon and Gary Y. Okihiro (New York: W.W. Norton, 2006).

11. Valerie Matsumoto, "Japanese American Women during World War II," in *Unequal Sisters: A Multicultural Reader in US Women's History*, ed. Ellen DuBois and Vicki Ruiz (New York: Routledge): 373–86.

PLATES

The historical photographs included in this book are from the photographic file of the War Relocation Authority—the government agency charged with administering each of the internment sites. The accompanying texts are the original unedited captions included with the photographs. All historical images are from Records of the War Relocation Authority, Record Group 210, National Archives, Still Picture Records and Special Media Archives Services Division, College Park, Maryland.

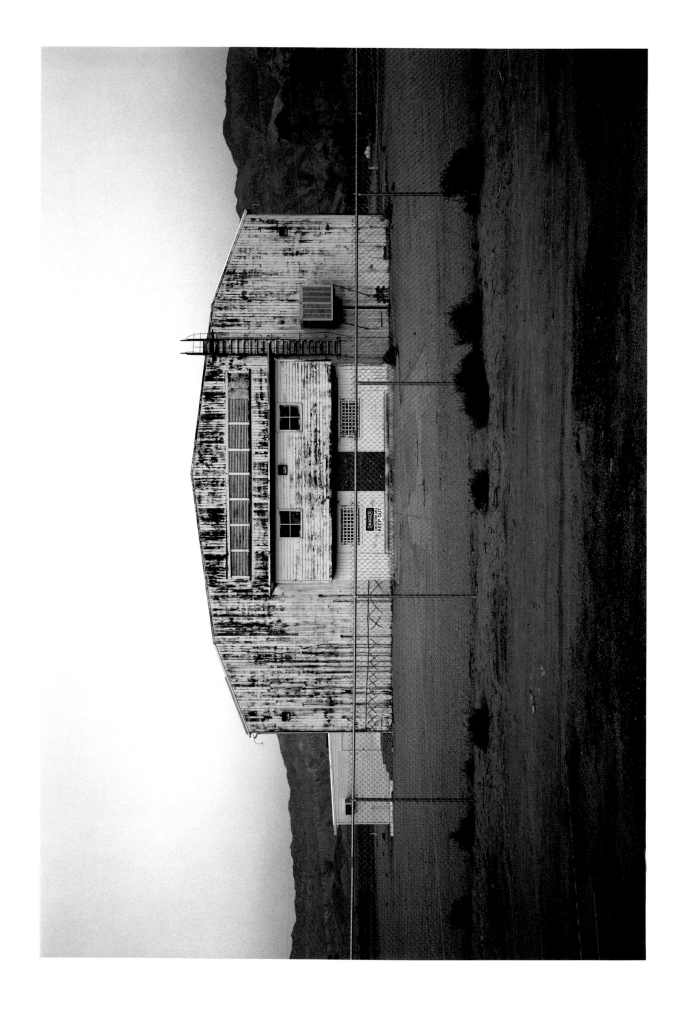

Auditorium, Manzanar Relocation Center, 1999

Los Angeles, California. Evacuees of Japanese ancestry entraining for Manzanar, California, 250 miles away, where they are now housed in a War Relocation Authority center. Photographer, Clem Albers. [NAIL Control Number: NWDNS-210-G-B16]

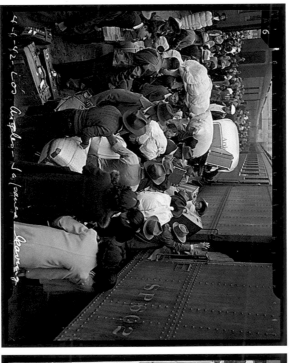

Manzanar Relocation Center, Manzanar, California. An evacuee family of Japanese descent is assisted by an evacuee nurse upon their arrival at this War Relocation Authority center. Photographer, Clem Albers. [NAIL Control Number: NWDNS-210-G-A297]

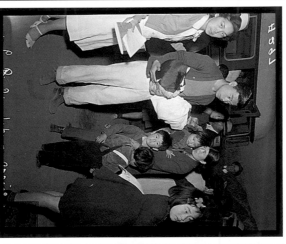

Manzanar Relocation Center, Manzanar, California. Mother and child, evacuees from the west coast, arriving at the Manzanar Relocation Center. Photographer, Clem Albers. [NAIL Control Number: NWDNS-210-G-A286]

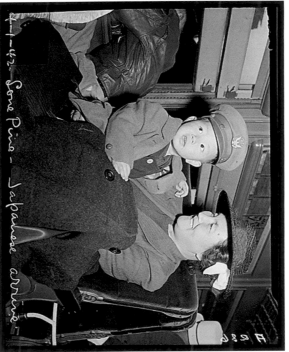

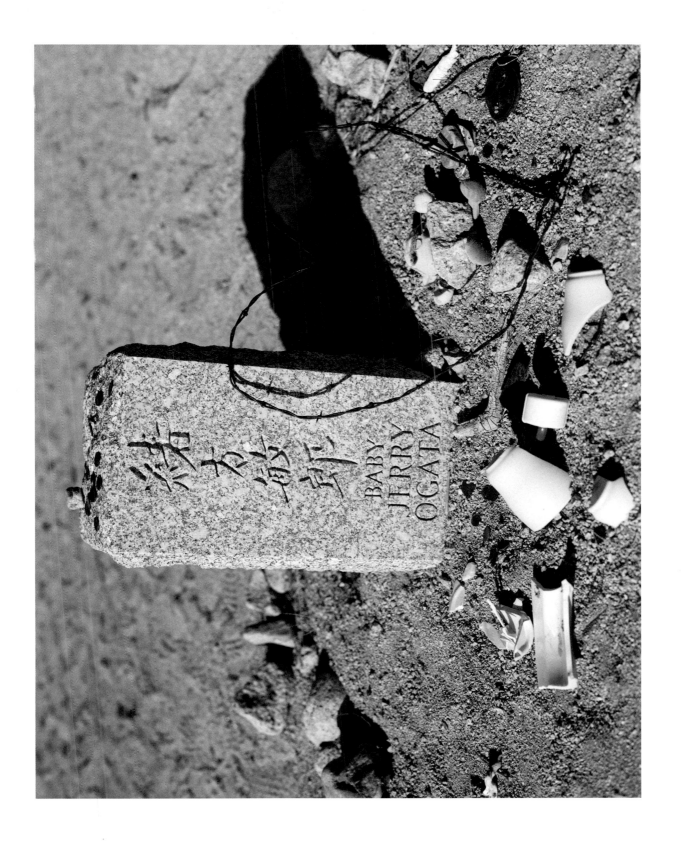

CHILD'S GRAVE, CEMETERY, MANZANAR RELOCATION CENTER, 1999

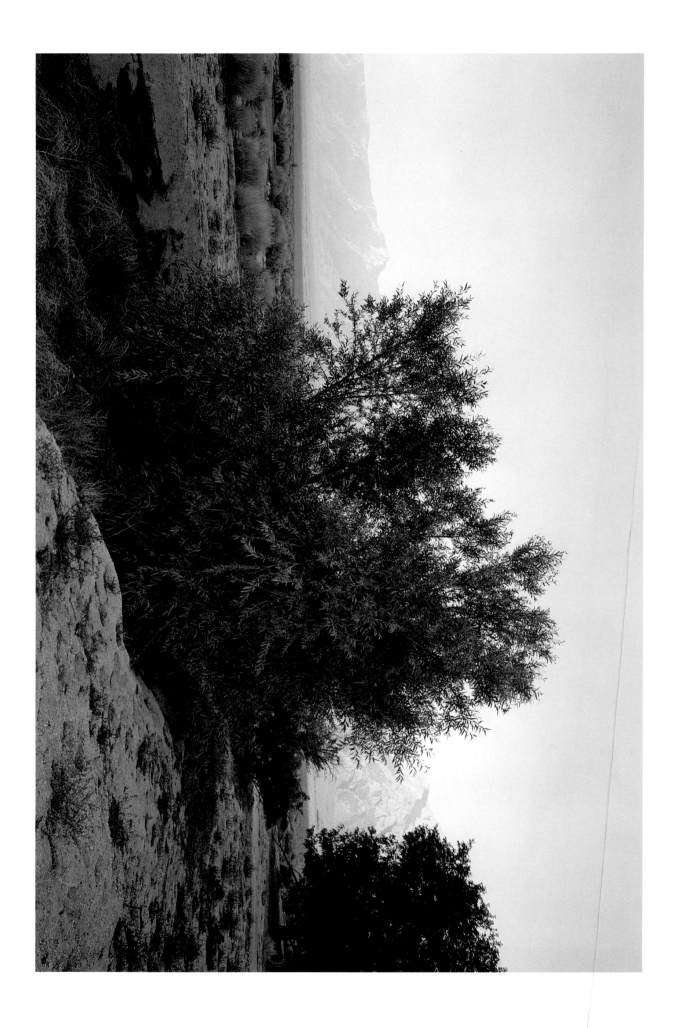

WILLOW AND SIERRA NEVADAS, MANZANAR RELOCATION CENTER, 1999

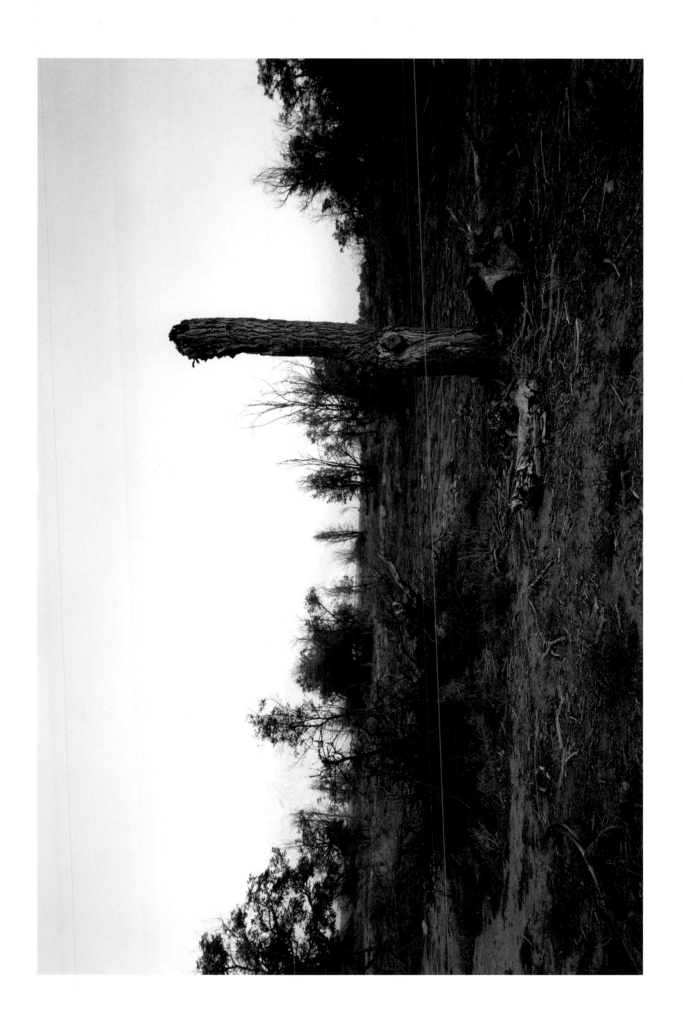

SUNRISE, MANZANAR RELOCATION CENTER, 1999

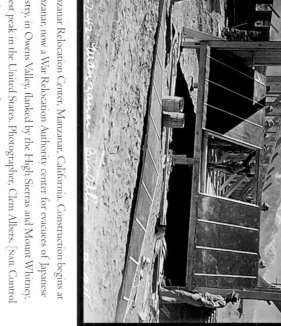

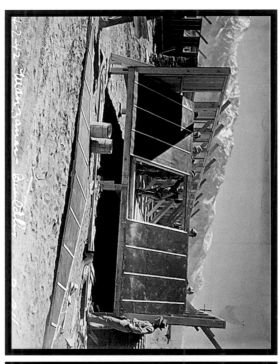

Manzanar Relocation Center, Manzanar, California. Construction begins at Manzanar, now a War Relocation Authority center for evacuees of Japanese ancestry, in Owens Valley, flanked by the High Sierras and Mount Whitney, loftiest peak in the United States. Photographer, Clem Albers. [NAIL Control Number: NWDNS-210-G-B94]

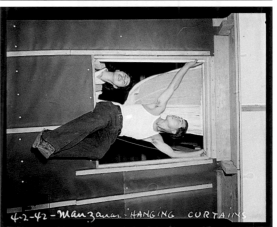

Manzanar Relocation Center, Manzanar, California. Hanging curtains in their barrack apartment at this War Relocation Authority for evacuees of Japanese ancestry. Photographer, Clem Albers. [NAIL Control Number: NWDNS-210-G-B95]

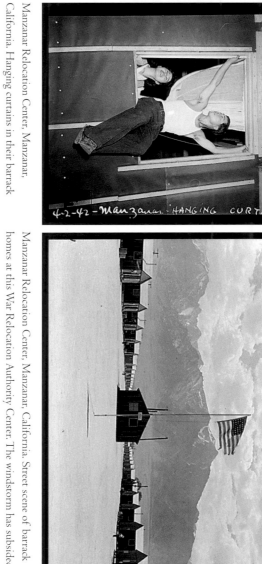

Manzanar Relocation Center, Manzanar, California. Street scene of barrack homes at this War Relocation Authority Center. The windstorm has subsided and the dust has settled. Photographer, Dorothea Lange. [NAIL Control Number: NWDNS-210-G-c840]

Foundation Ruins, Residential Area, Granada Relocation Center, 2000

Barracks, Tule Lake Relocation Center, 2001

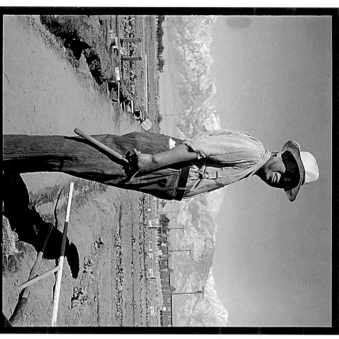

Manzanar Relocation Center, Manzanar, California. This evacuee is foreman of the "hobby gardens" project at this War Relocation Authority center. Photographer, Dorothea Lange. [NAIL Control Number: NWDNS-210-G-C712]

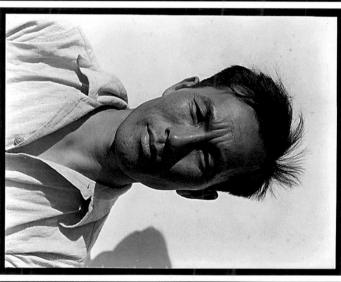

Manzanar Relocation Center, Manzanar, California. Karl Yoneda, Block Leader at this War Relocation Authority center for evacuees of Japanese ancestry. He is married to a Caucasian and they have a child four years old. The family are spending the duration at this center. Photographer, Dorothea Lange. [NAIL Control Number: NWDNS-210-G-C711]

Manzanar Relocation Center, Manzanar, California. Ogura Shuichi, born in Pasadena. He attended Pasadena Junior College and was a visiting student at the California Institute of Technology. He is now working as a plant statistician for the guayule rubber experiment project at this War Relocation Authority center for evacuees of Japanese ancestry. Photographer, Dorothea Lange. [NAIL Control Number: NWDNS-210-G-C710]

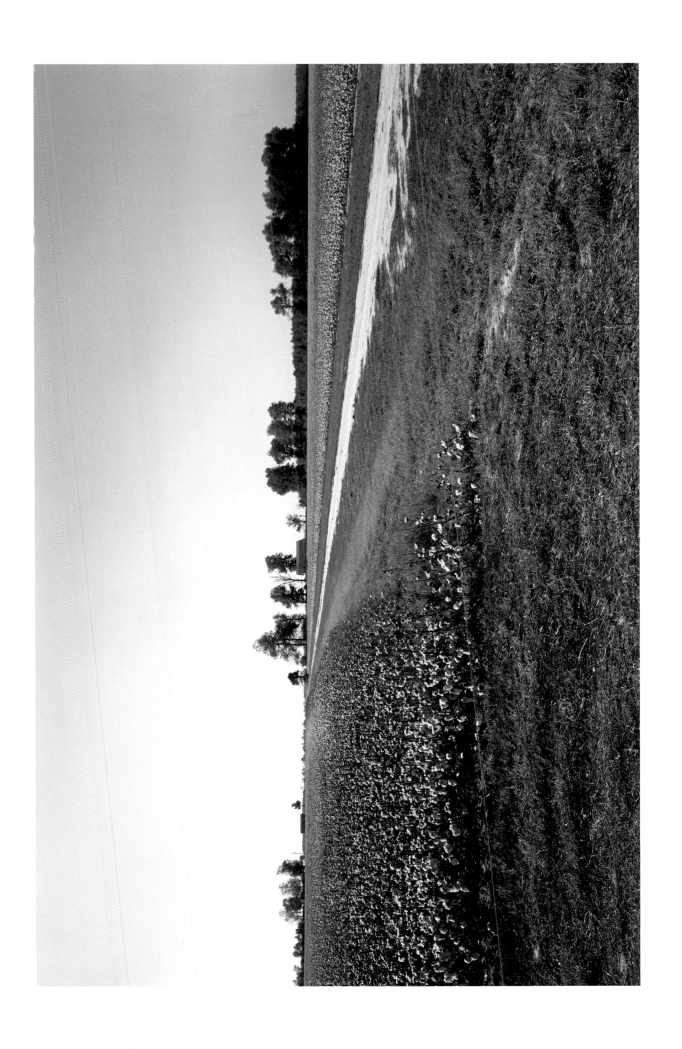

COTTON FIELD, ROHWER RELOCATION CENTER, 2001

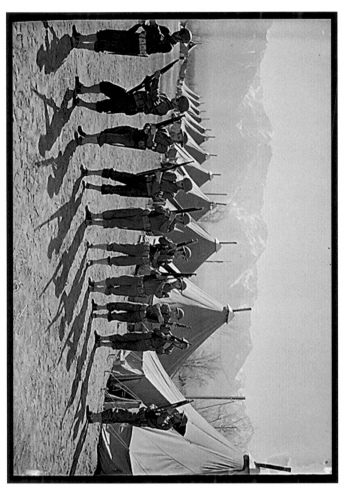

Manzanar, California. Military Police at assembly center for persons of Japanese ancestry evacuated from coastal areas. Photographer, Clem Albers. [NAIL Control Number: NWDNS-210-G-C48]

PALM TREE AND FARM FIELDS, POSTON RELOCATION CENTER, 2000

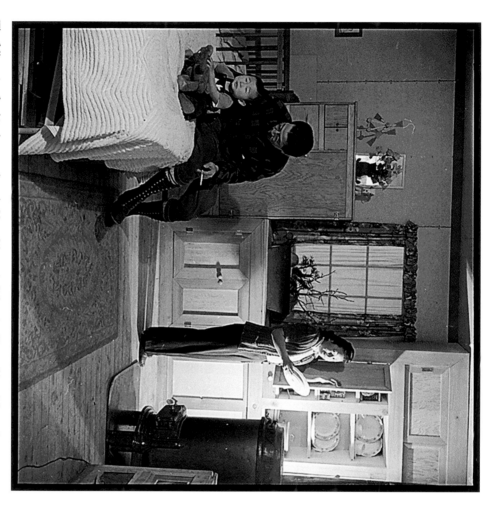

The full caption for this photograph reads: Heart Mountain Relocation Center, Heart Mountain, Wyoming. A few pieces of scrap and some additional mail order lumber, and the ingenuity of skilled hands, have converted a bare barracks room into a home of some comfort. Many residents, such as the young Nisei family shown, have through their own ingenuity, bettered their living conditions within the center. Photographer, Tom Parker. [NAIL Control Number: NWDNS-210-617]

INTERIOR OF HOSPITAL MESS HALL, HEART MOUNTAIN RELOCATION CENTER, 2000

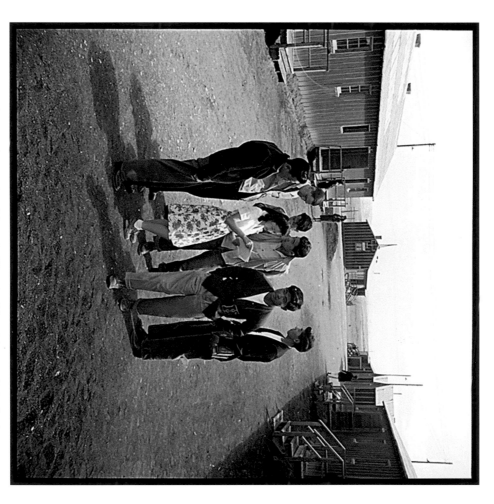

Heart Mountain Relocation Center, Heart Mountain, Wyoming. Heart Mountain high school campus scene. Classes are housed in tarpaper-covered, barrack-style buildings originally designed as living quarters for the evacuees. Photographer, Bill Hosokawa. [NAIL Control Number: NWDNS-210-G-B555]

WALKWAY, ELEMENTARY SCHOOL, POSTON RELOCATION CENTER, 2000

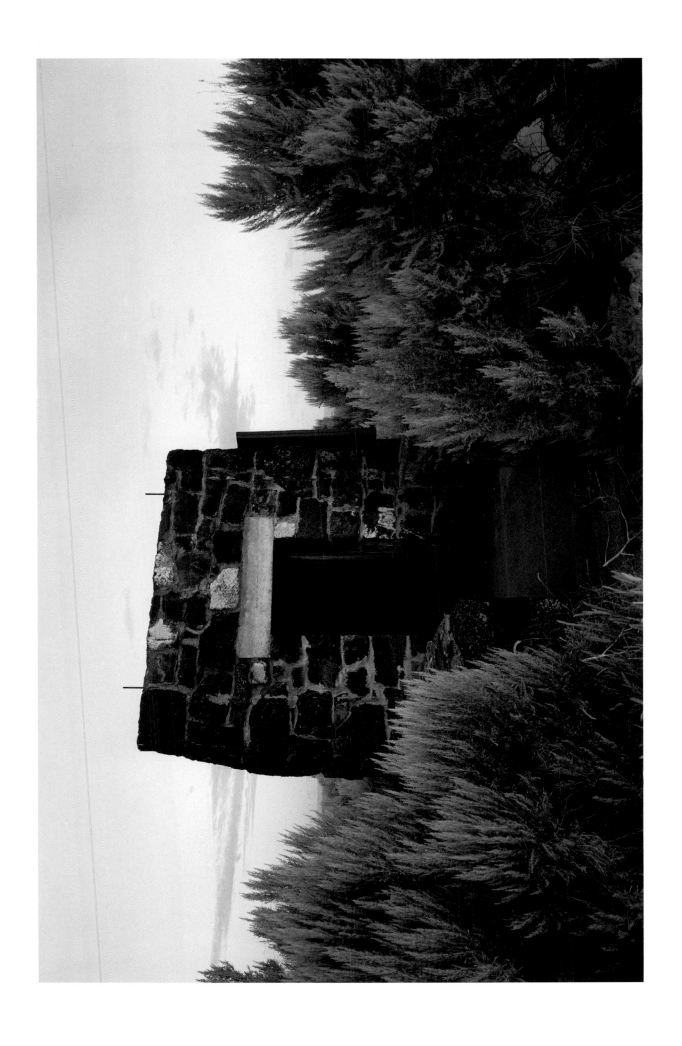

GUARD STATION, MINIDOKA RELOCATION CENTER, 2000

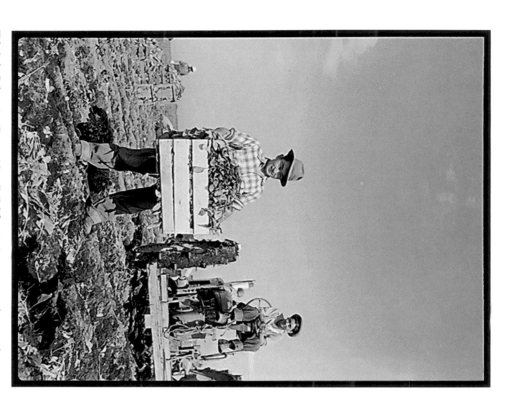

Tule Lake Relocation Center, Newell, California. An evacuee is shown with a crate of spinach. His smile is proud of the high quality of this crop. Photographer, Francis Stewart. [Natl Control Number: NWDNS-210-G-D198]

MODERN MIGRANT WORKER HOUSING, TULE LAKE RELOCATION CENTER, 2001

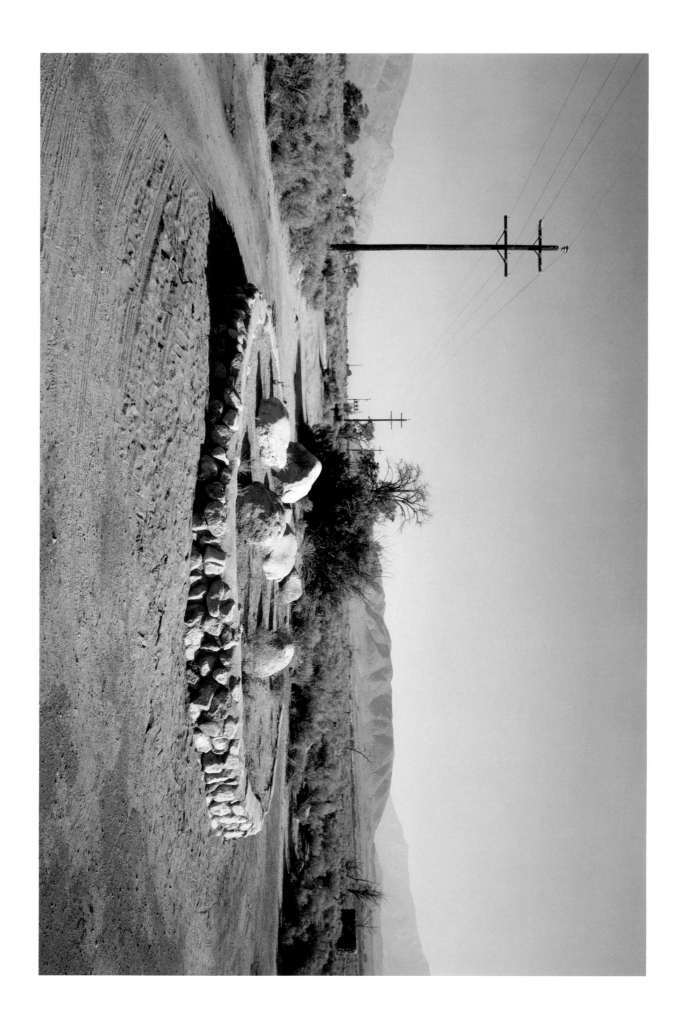

ROUNDABOUT, ADMINISTRATIVE AREA, MANZANAR RELOCATION CENTER, 1999

Sidewalk, Administrative Area, Manzanar Relocation Center, 1999

Looking toward the Hospital and Administrative Area, Heart Mountain Relocation Center, 2002

Looking toward the Hospital and Administrative Area, Heart Mountain Relocation Center, 2002

SIDEWALK, ADMINISTRATIVE AREA, MANZANAR RELOCATION CENTER, 1999

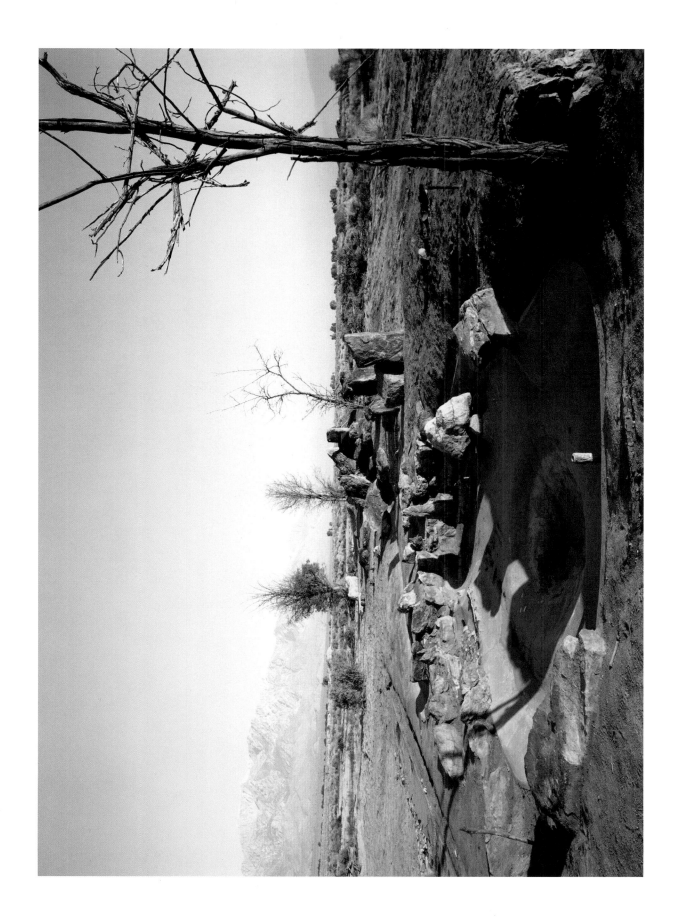

GARDEN REMAINS, MANZANAR RELOCATION CENTER, 1999

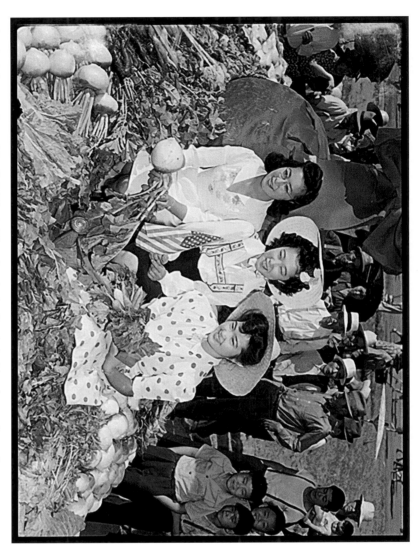

Tule Lake Relocation Center, Newell, California. The prize winning float in the labor day parade was the one entered by the Agricultural Division. These three pretty evacuee girls display the prize vegetables which were grown on the farm at this relocation center. Photographer, Francis Stewart. [NAIL Control Number: NWDNS-210-G-D216]

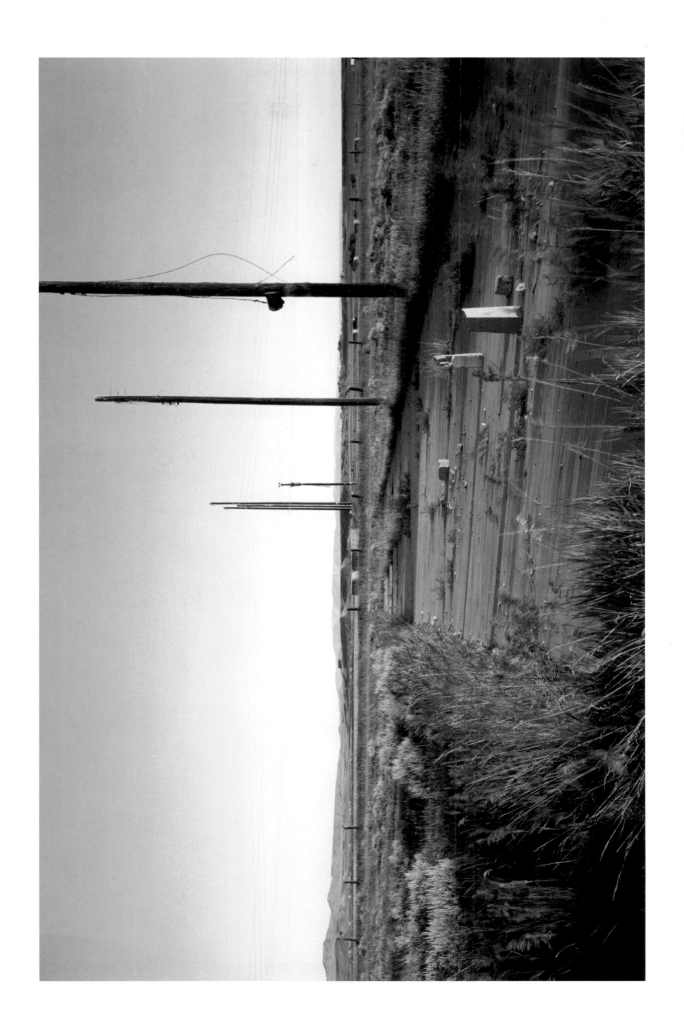

Foundation Remains in the Hospital Area, Heart Mountain Relocation Center, 2000

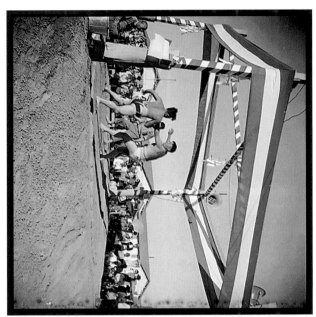

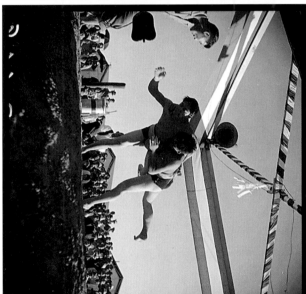

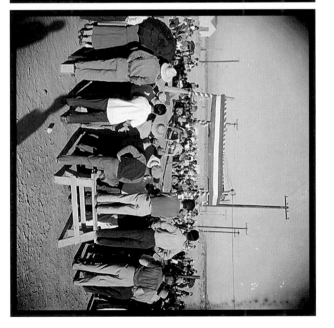

Gila River Relocation Center, Rivers, Arizona. A wrestling tournament was held by the evacuees Thanksgiving day at this center. Photographer, Francis Stewart. [NAIL Control Number: NWDNS-210-G-D671], [NAIL Control Number: NWDNS-210-G-D668], [NAIL Control Number: NWDNS-210-G-D672]

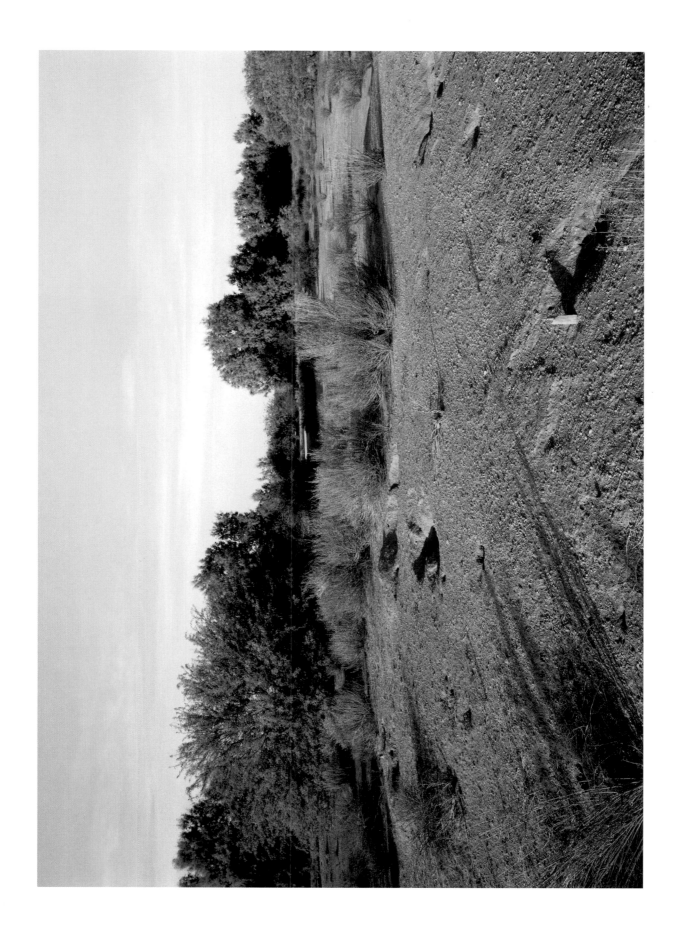

Site of Sumo Wrestling Arena, Gila River Relocation Center, 2002

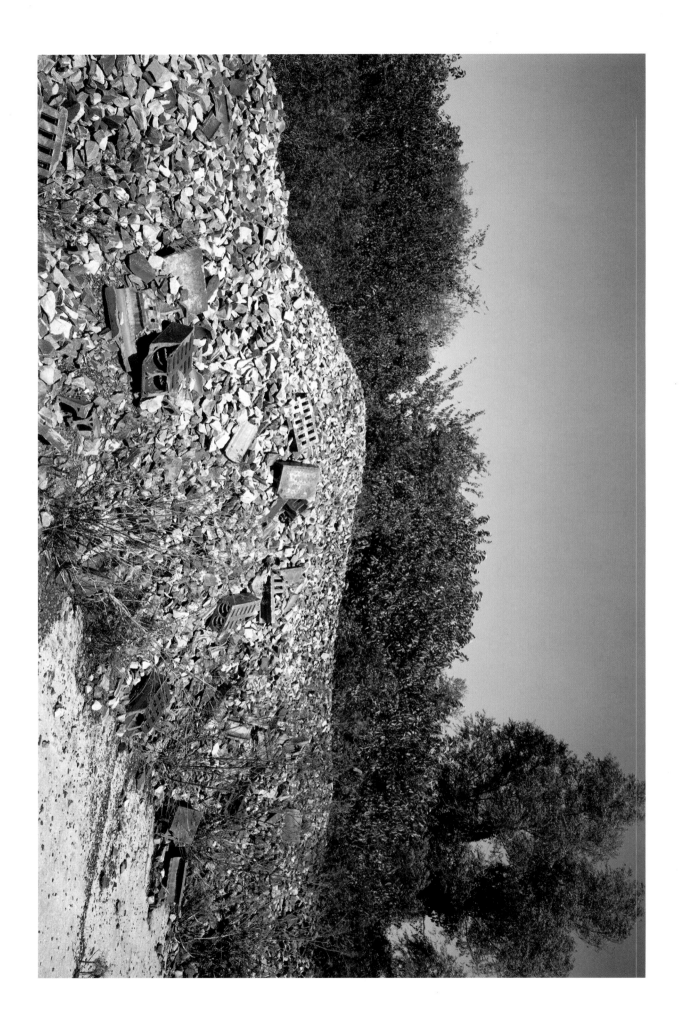

Rubble in the Area around Camp's Sewage Treatment Facility, Jerome Relocation Center, 2001

Downed Palms, Poston Relocation Center, 2000

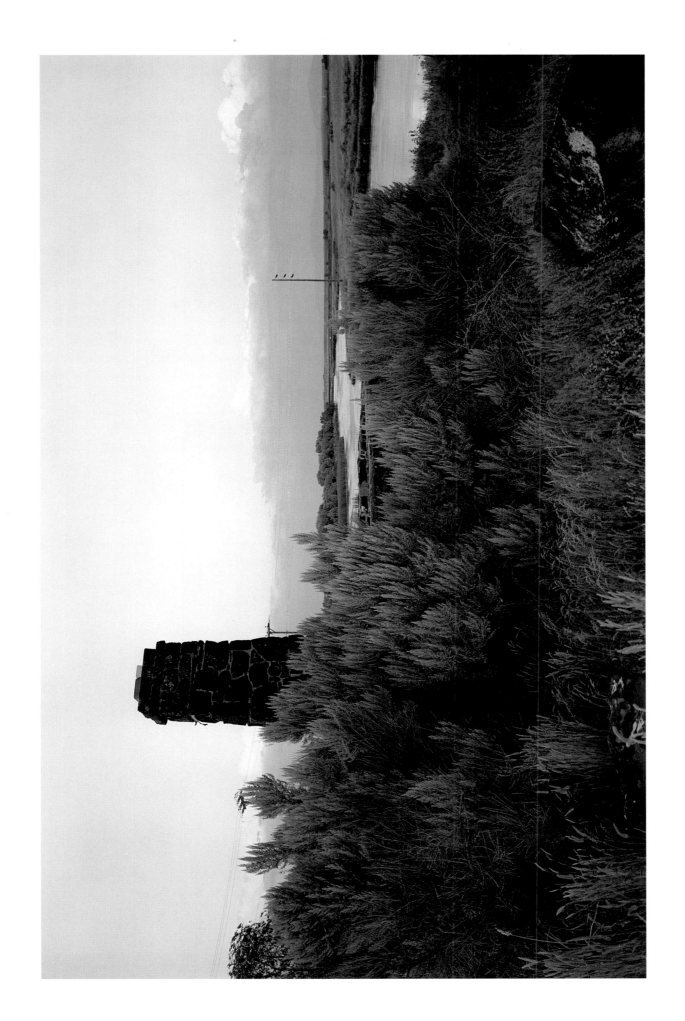

CHIMNEY, VISITORS' WAITING ROOM, MINIDOKA RELOCATION CENTER, 2000

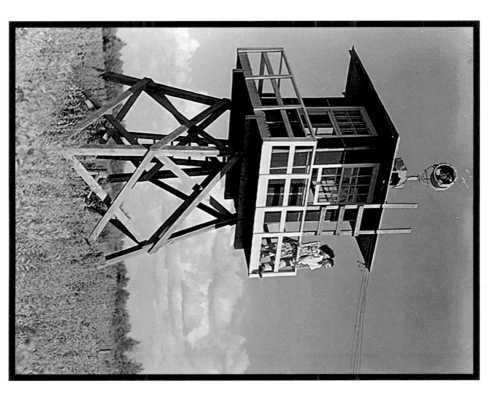

Closing of the Jerome Relocation Center, Denson, Arkansas. Clara Hasegawa and Tad Mijake take a last look at the Jerome Center from the balcony of one of the camp's guard towers. The towers have not been manned since segregation was completed during the latter part of 1943 and have been popular with the young folks as a place of rendezvous. This young couple will take up their new residence at the Rohwer Center. Photographer, Charles E. Mace. [NAIL Control Number: NWDNS-210-G-H414]

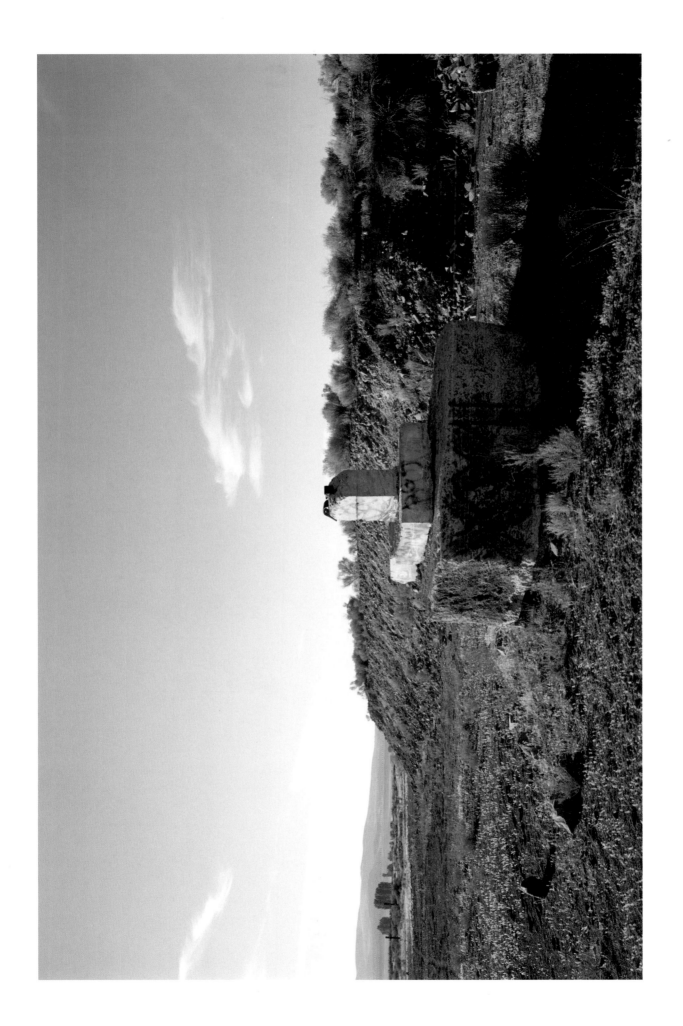

WATCHTOWER FOUNDATION BLOCKS, TULE LAKE RELOCATION CENTER, 2001

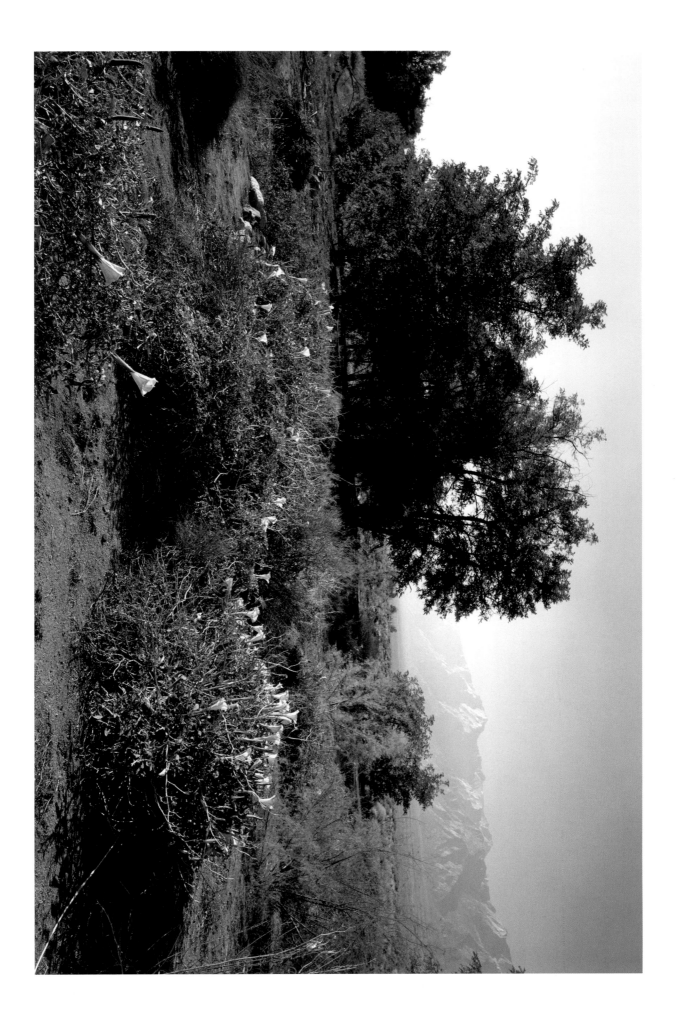

↓

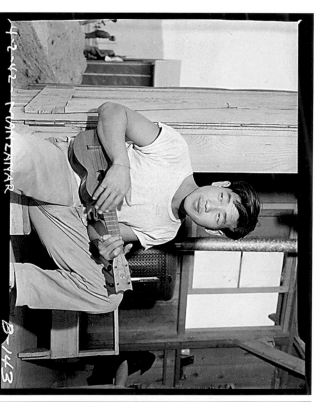

Manzanar Relocation Center, Manzanar, California. A "uku" [ukulele] affords amusement for young evacuee at this War Relocation Authority center. Photographer, Clem Albers. [NAIL Control Number: NWDNS-210-G-B143]

Manzanar Relocation Center, Manzanar, California. Yaeko Yamashita (in doorway) watches Fugiko Koba trying a new pair of geta, which are stilt-like sandals especially useful in dust. They are evacuees of Japanese descent now living at this War Relocation Authority center. Photographer, Clem Albers. [NAIL Control Number: NWDNS-210-G-B14]

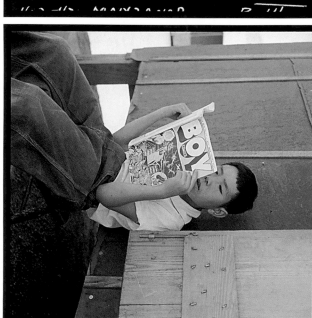

Manzanar Relocation Center, Manzanar, California. Evacuee boy at this War Relocation Authority center reading the Funnies. Photographer, Dorothea Lange. [NAIL Control Number: NWDNS-210-G-C783]

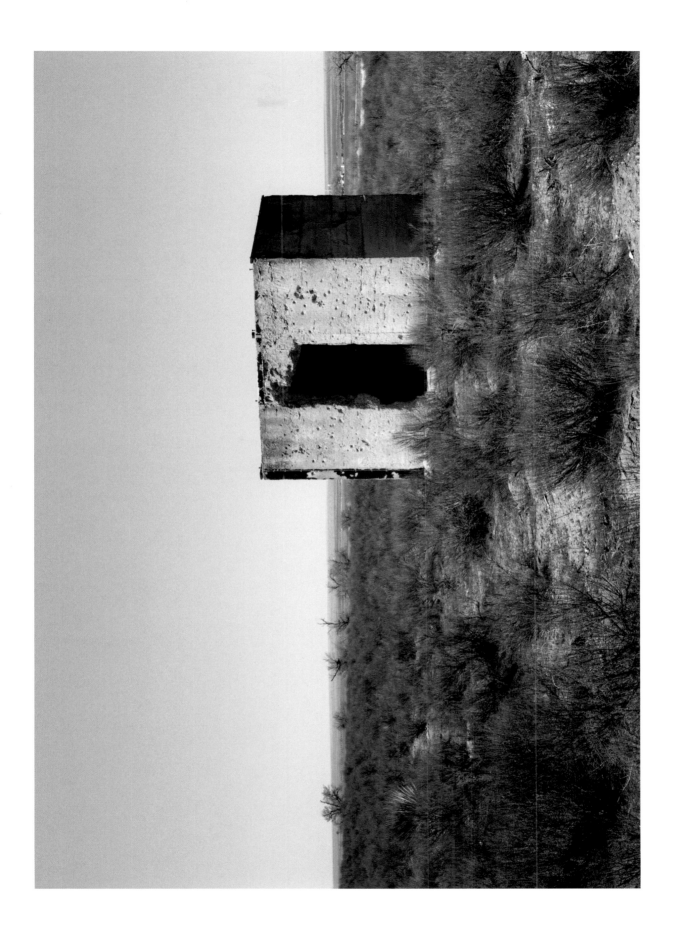

BUILDING IN CO-OP AREA, GRANADA RELOCATION CENTER, 2000

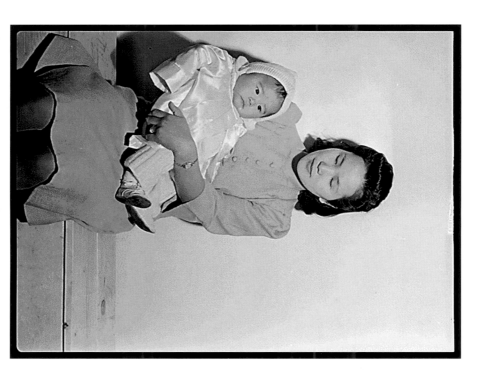

Tule Lake Relocation Center, Newell, California. This picture of mother and child was taken for evacuee use. This picture is interesting from a documentary angle, however, for it shows the proud mother holding the doll-like featured child. Photographer, Francis Stewart. [NAIL Control Number: NWDNS-210-G-D250]

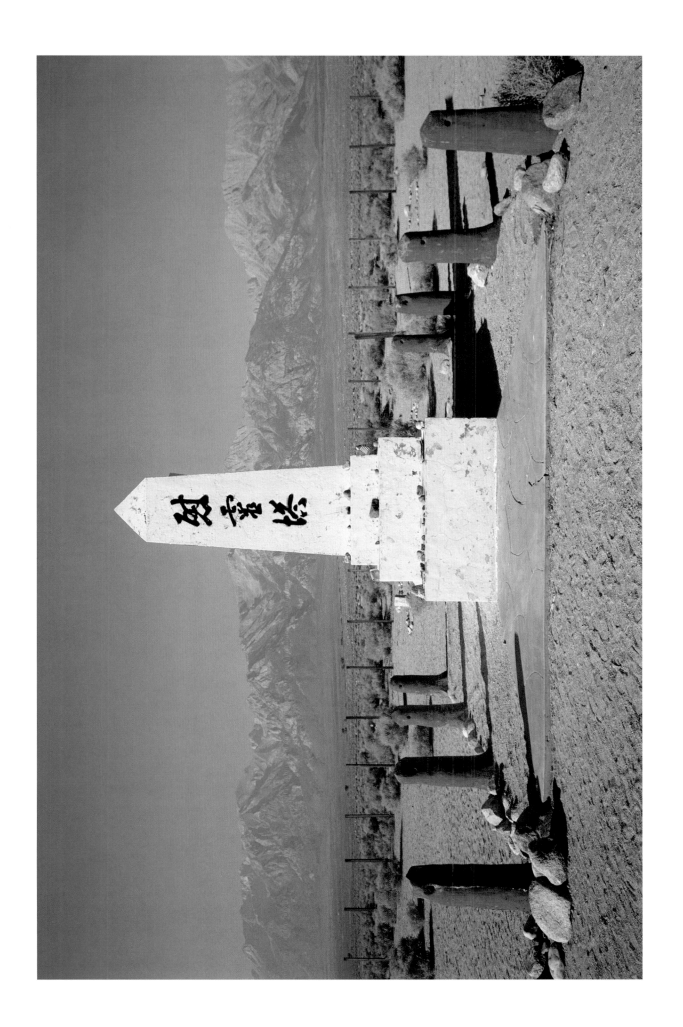

MEMORIAL IN CEMETERY, MANZANAR RELOCATION CENTER, 1999

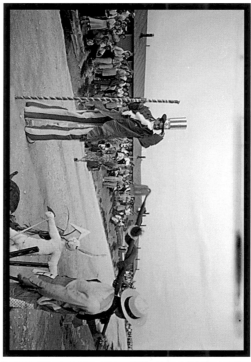

Granada Relocation Center, Amache, Colorado. Amache Summer Carnival Parade, 07/10/1943; Photographer, Joe McClelland. [NAIL Control Number: NWDNS-210-G-B675]

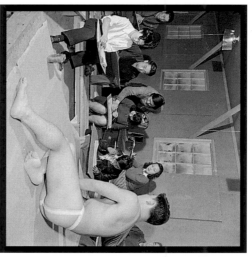
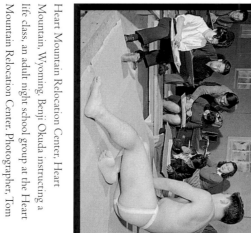

Heart Mountain Relocation Center, Heart Mountain, Wyoming. Benji Okuda instructing a life class, an adult night school group at the Heart Mountain Relocation Center. Photographer, Tom Parker. [NAIL Control Number: NWDNS-210-G-E101]

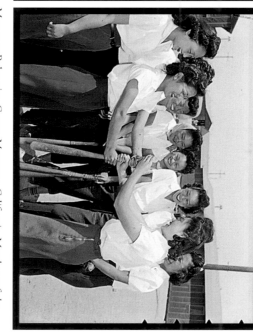

Manzanar Relocation Center, Manzanar, California. Members of the Chick-a-dee soft ball team from Los Angeles choose sides for a practice game at Manzanar, where, since evacuation, the girls have kept their team intact. The squad leaders, with hands on bar, are: Ritsuko Masuda (left), and Marion Fujii. Photographer, Francis Stewart. [NAIL Control Number: NWDNS-210-G-D527]

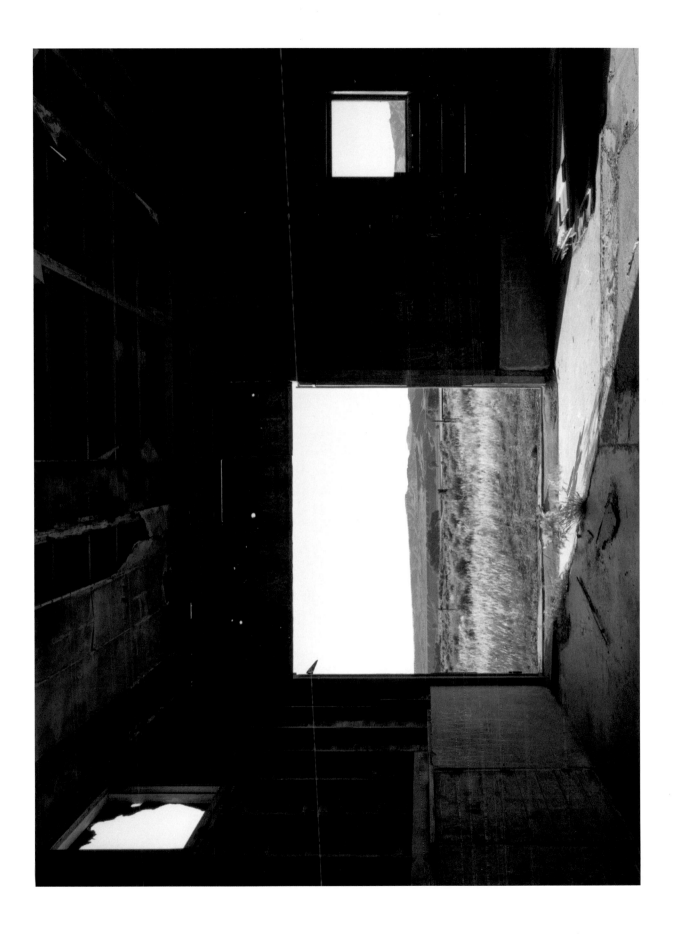

VIEW FROM HOSPITAL BOILER HOUSE, HEART MOUNTAIN RELOCATION CENTER, 2000

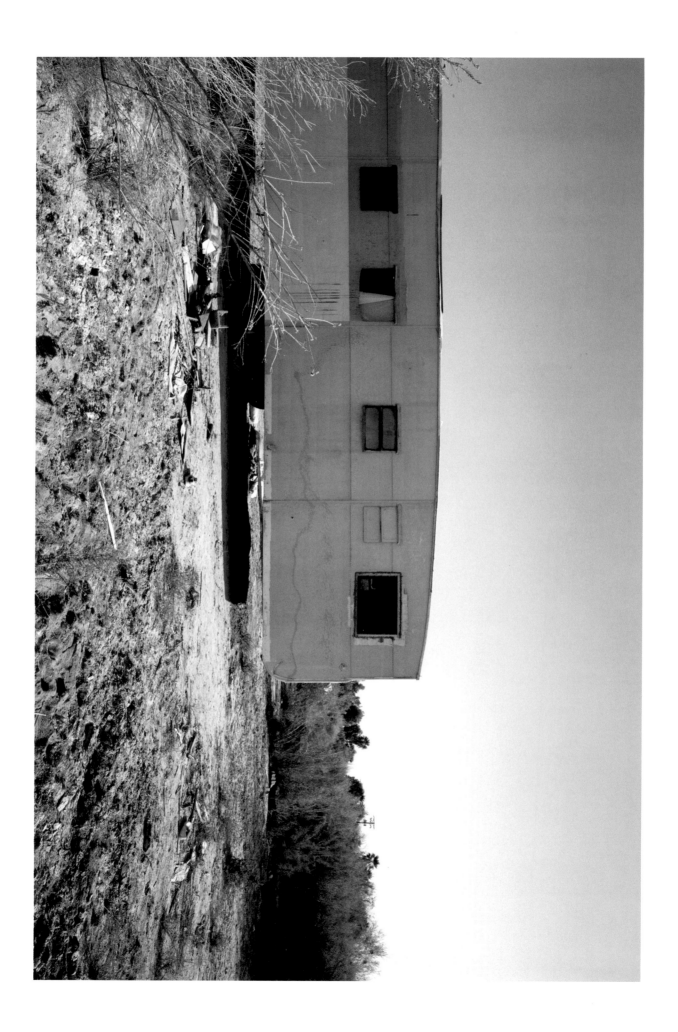

Trailer near Fire Station, Poston Relocation Center, 2000

Elementary School Building, Poston Relocation Center, 2000

View from the Cemetery, Rohwer Relocation Center, 2001

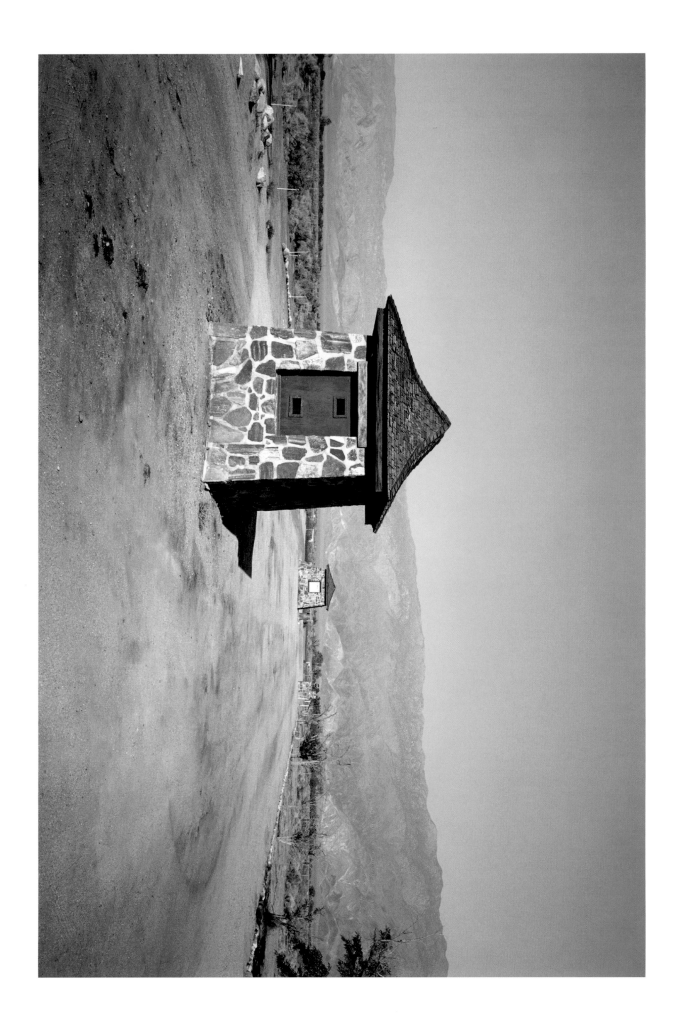

GUARD STATIONS, ENTRANCE TO MANZANAR RELOCATION CENTER, 1999

ELEMENTARY SCHOOL AUDITORIUM, POSTON RELOCATION CENTER, 2000

84 | 85

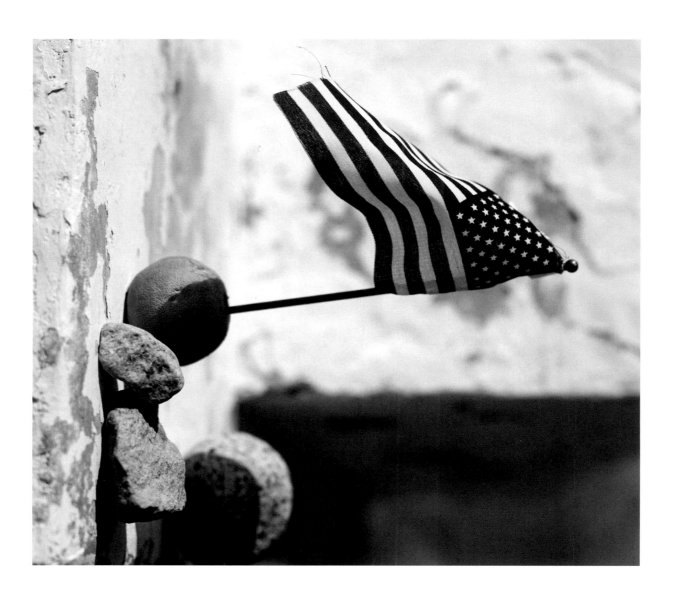

Monument to Servicemen, Cemetery, Rohwer Relocation Cemetery, 2001

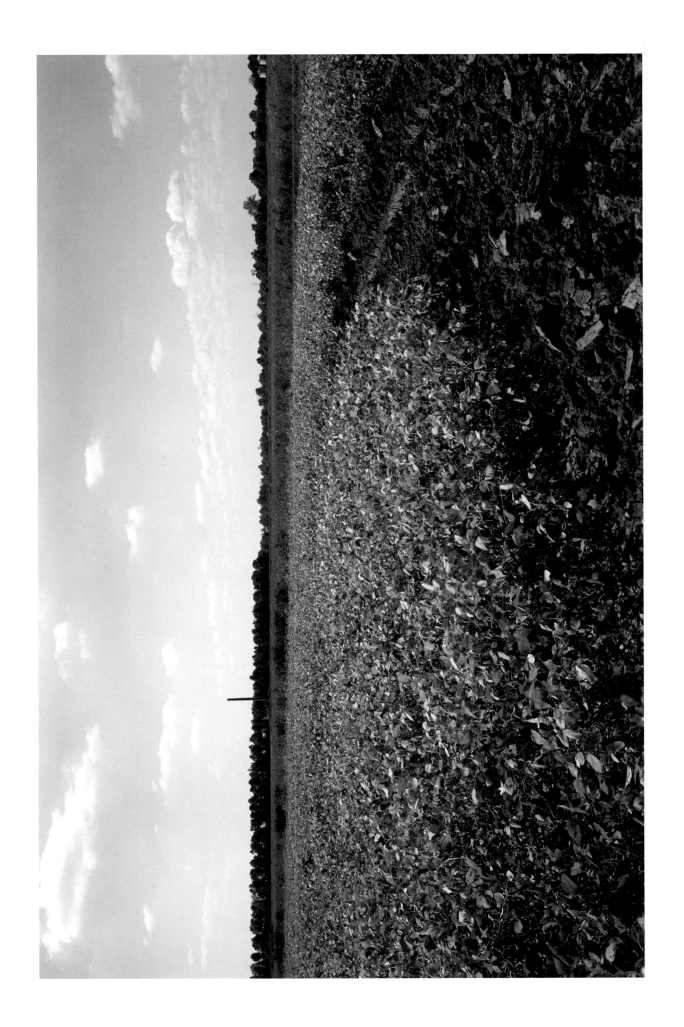

Soybean Field and Smokestack from Hospital Boiler House, Jerome Relocation Center, 2001

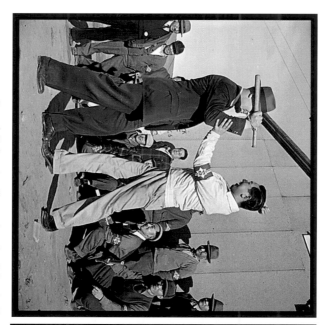

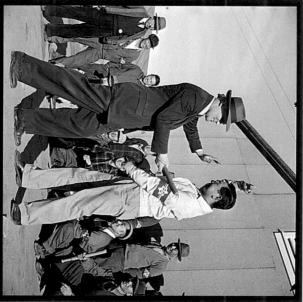

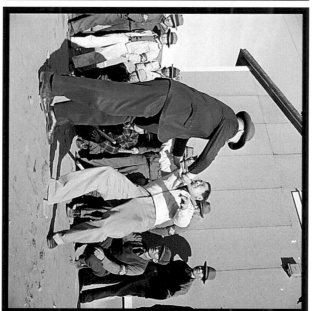

Granada Relocation Center, Amache, Colorado. To a class of volunteer center police, Internal Security Director, Tomlinson, formerly a city police captain, demonstrates effective police gro club use. Photographer, Tom Parker. [NAIL Control Number: NWDNS-210-G-E544]. [NAIL Control Number: NWDNS-210-G-E535]. [NAIL Control Number: NWDNS-210-G-E534]

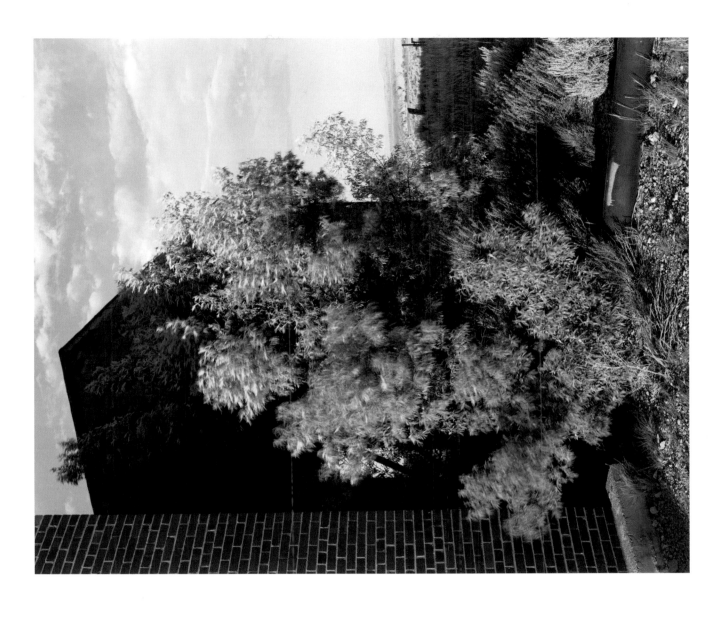

HOSPITAL BOILER HOUSE, HEART MOUNTAIN RELOCATION CENTER, 2000

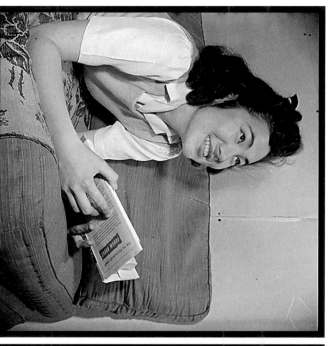

Manzanar Relocation Center, Manzanar, California. Lucy Yonemitshu, former student from Los Angeles, California, enjoys a pleasant afternoon with her book. Lucy lives with her parents in this barrack home, which has been very tastefully decorated by her father. Photographer, Francis Stewart. [NAIL Control Number: NWDNS-210-G-B181]

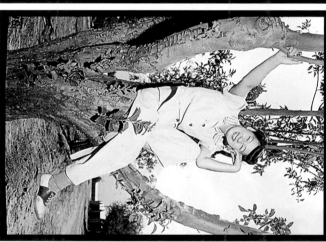

Manzanar Relocation Center, Manzanar, California. Kinu Hirashima, from Los Angeles, perches in an apple tree at Manzanar, a War Relocation Authority center where evacuees of Japanese ancestry will spend the duration. Photographer, Francis Stewart. [NAIL Control Number: NWDNS-210-G-D552]

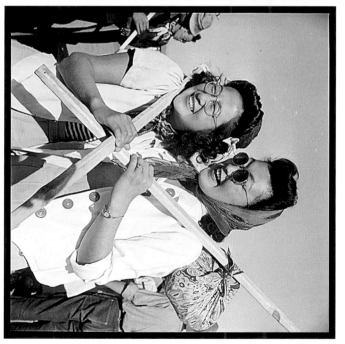

Tule Lake Relocation Center, Newell, California. Two pretty evacuees shouldered their lunch and hiked into the foothills for a labor day picnic. Photographer, Francis Stewart. [NAIL Control Number: NWDNS-210-G-D205]

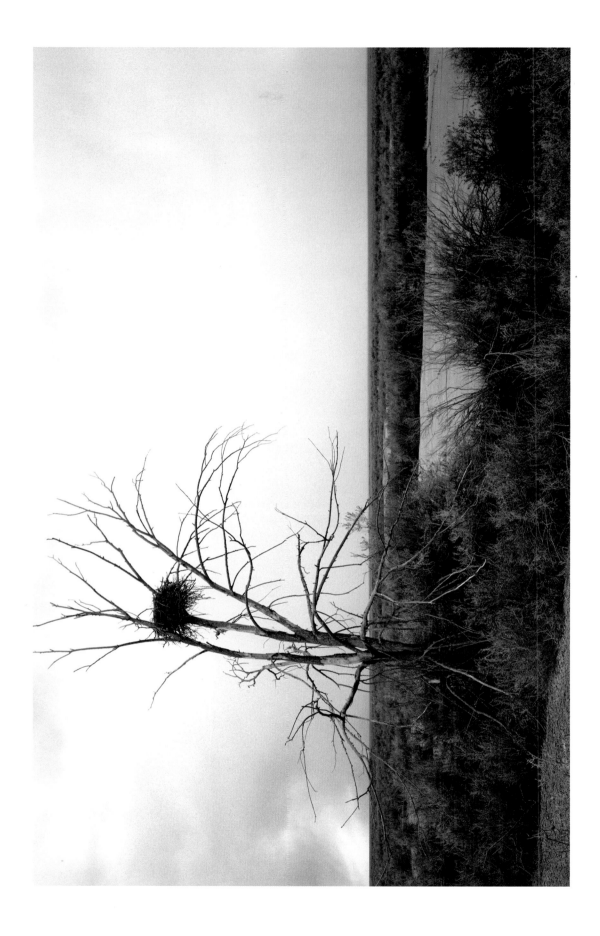

BIRD'S NEST, TOPAZ RELOCATION CENTER, 2000

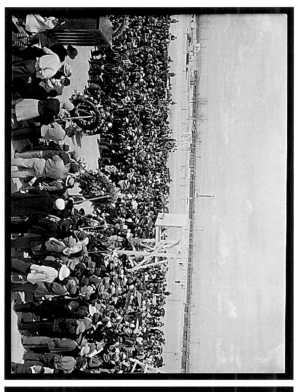

Topaz, Utah, James Wakasa funeral scene. (The man shot by military sentry.) 04/19/1943; Photographer, Russell A. Bankson. [NAIL Control Number: NWDNS-210-G-C917]

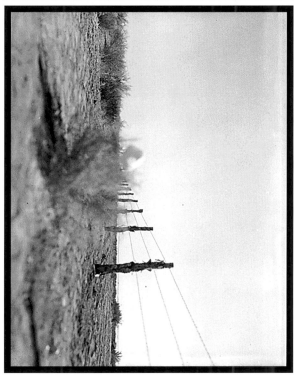

The full caption for this photograph reads: Topaz Utah, Army Volunteers, 1942–1945, Photographer, Not Noted. [NAIL Control Number: NWDNS-210-G-C914] *Note:* Obviously miscaptioned, this image was found in the file among photographs from James Wakasa's funeral, an internee shot by a military sentry when he wandered too close to the fence line.

FENCE LINE, TULE LAKE RELOCATION CENTER, 2001

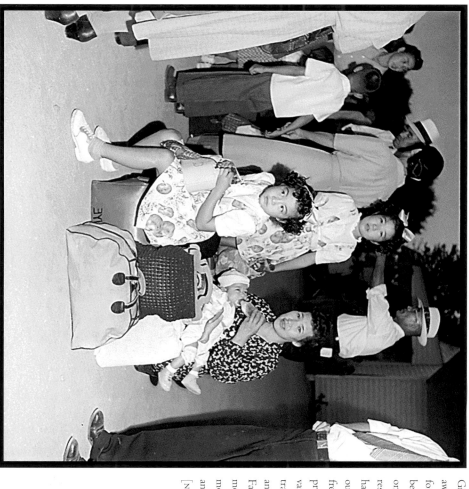

Gila River Relocation Center, Rivers, Arizona. Center residents awaiting the arrival of the bus which will carry them to their former homes on the west coast. On September 15, two weeks before the Canal Camp at Rivers, Arizona, was to close, only 635 people remained and 370 of these had bus or train reservations for the following week (the Canal Camp once had more than 5,000 residents). Most of the people are going out by special Greyhound buses. Their property, crated for freight shipment, is picked up at their homes and stored in project warehouses until it is loaded on the heavy trucking vans. Before the relocators leave the Center they secure their travel vouchers and their ration books from the Leave Office and get their special Relocation Grant from the Agent Cashier. Farm machinery, once used in the production of vegetables and melons for Gila and other centers, now is assembled ready to be moved from the Center. All the livestock is gone and buildings and fences are being torn down. Photographer, Hikaru Iwasaki.

[NAIL Control Number: NWDNS-210-G-K525]

AIRPORT, TULE LAKE RELOCATION CENTER, 2001

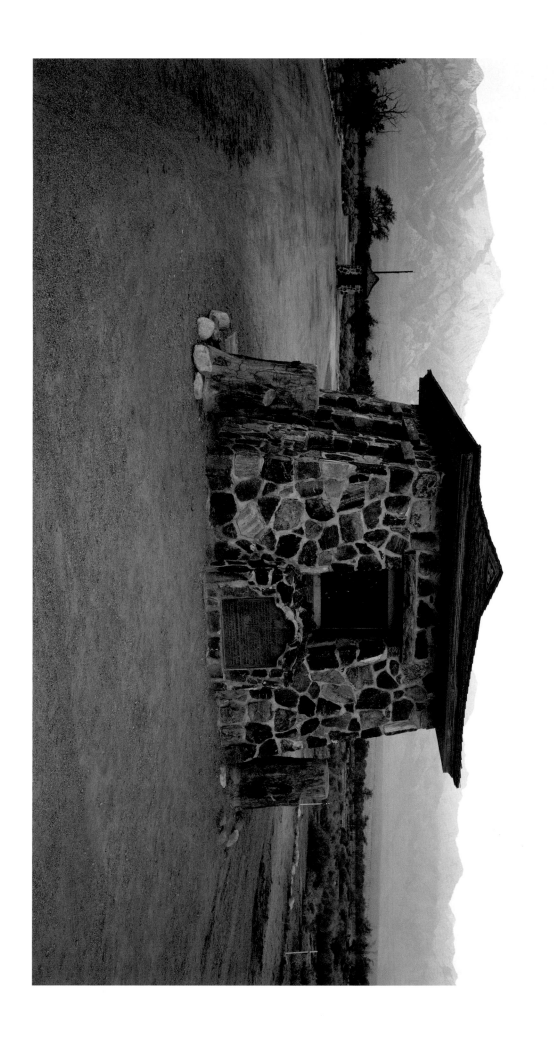

GUARD STATION, MANZANAR RELOCATION CENTER, 1999

Camp Road, Manzanar Relocation Center, 1999

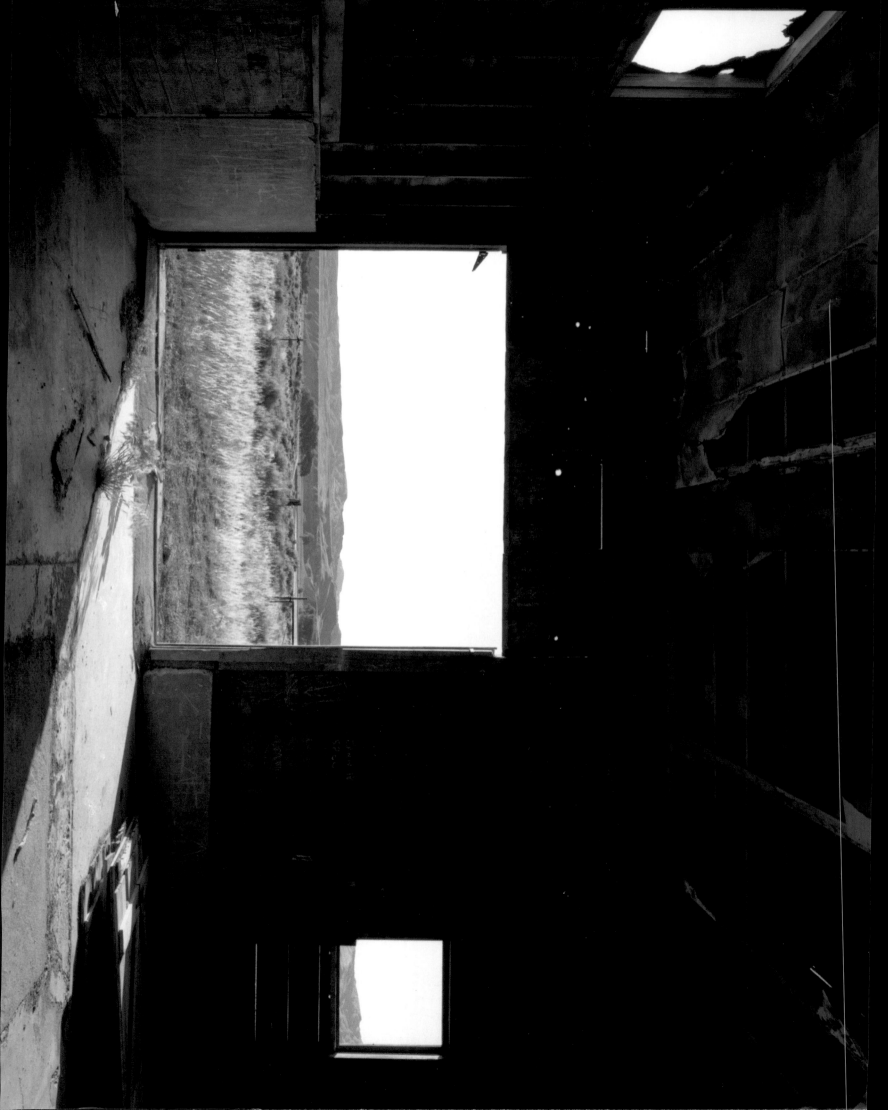

JOHN TATEISHI

AFTERWORD

"A picture is worth a thousand words." This old Chinese proverb finds no truer expression than in the images of this book, a collection of archival government photos set beside photos by a professional photographer, Todd Stewart. These images are both special and profound, for they tell the story of America's ten concentration camps, echoing back the names of America's shame: Manzanar, Topaz, Gila River, Poston, Tule Lake, Heart Mountain, Minidoka, Amache, Rohwer, Jerome. The images presented here reawaken the story of these camps, quietly buried away in American history, just as the lives of those who endured these desolate, forsaken prisons were buried away in a shame and guilt they never understood. They understood only that their lives were shattered.

The story of the World War II internment of Americans of Japanese ancestry is an intriguing one, for it begs the question of why the U.S. government failed to protect the rights of American citizens and to uphold the Constitution. At that moment in time, when the nation faced unparalleled adversity and tragedy, its treatment of Japanese Americans could have been a story of a shining moment of courageous leadership. Instead, it is a story of manipulation, blatant racism, political pandering, and a staggering failure of leadership by the president and others who were sworn to ensure the sanctity of American democracy.

The entire population of Japanese Americans was forced from their homes at gunpoint and placed in America's concentration camps, the only time in U.S. history that an entire segment of the American population was denied its birthrights guaranteed by the Bill of Rights and the Constitution. In violation of all American principles of democracy, Japanese Americans were forced from their homes and placed against their will in American prisons.

Their crime? Just that they happened to look like the enemy.

Many have argued that the exclusion and internment of Japanese Americans were justified. Some have argued that it was to protect the West Coast in the event of an invasion by the Japanese army and navy. Others have argued that Japan precipitated the government's action by attacking Pearl Harbor and killing over two thousand American sailors. Still others have argued that the internment of Japanese Americans was a benevolent act borne of concern for the safety of the West

Coast Japanese population to protect them from mob violence and vigilantes. It was for the safety of Japanese Americans, they argue.

The government's stated rationale was military necessity. The army, given command of the West Coast region, argued that in the event of a possible invasion by Japan, there was no way to determine who among the Japanese American population would be loyal to the United States. Japanese Americans, they argued, were an unknown quantity. Many of them had strong allegiances to Japan. Japanese immigrants, the argument continued, had made no attempt to assimilate into mainstream society in the western states where they had settled. They kept to themselves. They had never sought to become American citizens.

There is some truth to some of these arguments, but only because of policies forbidding Japanese Americans from participating fully in American society. The Issei (the immigrant generation), for example, unlike their European counterparts, were barred by a

federal law from becoming naturalized American citizens. If Japanese Americans lived in ghetto-like enclaves, it was because restrictive covenants established segregated communities. There was very little assimilation, because at that time all people of color were kept separate from white America. It was not by choice that Japanese Americans (or blacks or Latinos, for that matter) lived in enclave communities; they had no choice. Today, race still matters. In those days, race was a paramount dividing factor of life.

The question of loyalty among Japanese Americans should never have been raised, because the government already knew the answer. For ten years prior to the attack at Pearl Harbor, America's intelligence services (naval and army intelligence, the FBI) had conducted close surveillance of all the West Coast Japanese American communities and had determined that Japanese Americans would remain loyal to the United States in the event of an outbreak of war between the United States and Japan. To argue, therefore, that

the question of loyalty was a major factor in the decision to imprison Japanese Americans was bogus at best. Loyalty had nothing to do with the government's decision. Even as the president and the war department began preparing for the removal of Japanese Americans from their homes, Attorney General J. Edgar Hoover, never known for being soft on real or imagined enemies of the state, argued against internment. In an internal memorandum he even referred to the decision as "damned nonsense" and an affront to the intelligence agencies, who all concurred: there was no need to incarcerate Japanese Americans for they posed no threat to West Coast security.

The decision to force Japanese Americans from their homes was not a consequence of the attack on Pearl Harbor or the outbreak of war. It was the culmination of many years of effort by white supremacist organizations to exclude Asians from the West Coast states. For over fifty years, groups such as the Japanese Exclusion League, the Native Sons of the Golden West, the Grange Association, and others had campaigned unsuccessfully to rid the western states of their Japanese population. With the attack on Pearl Harbor and the outbreak of war in the Pacific, these groups found the perfect rationale to accomplish what they had not been able to do legally for over five decades.

Under pressure from the West Coast congressional delegation, President Franklin Roosevelt issued Executive Order 9066 on February 19, 1942, giving authority to the military to oversee security in the coastal regions. In the two months between the attack on Pearl Harbor and the issuance of this order, there were no proven charges of espionage or sabotage by any American of Japanese ancestry, although rumors were rampant. In that same period, there were no mob attacks on Japanese Americans or on their communities, which underlines the absurdity of the government's argument that the internment was necessary in order to protect the Japanese American population from mob violence.

Within days of the executive order, the military commander on the West Coast began issuing military proclamations intended to control the security of the coastal states. In March 1942 a military proclamation ordered a curfew and travel restrictions for Japanese Americans, and in the late spring the army issued orders to "evacuate." These orders were directed at all persons of Japanese ancestry, without regard to constitutional protections. One by one, the Japanese American communities were emptied of their residents as law enforcement officers and soldiers armed with rifles marched these loyal Americans from their homes and into America's concentration camps.

It mattered little at the time that these actions were in violation of the Constitution, and that the government never allowed these American citizens their constitutional rights to due process to prove their innocence. It mattered little that thousands of young men from the concentration camps, when given the opportunity, would volunteer for the U.S. Army

and would distinguish themselves by extraordinary service in the 442nd Regimental Combat Team. This team, for its size and length of service, won more medals for valor than any other unit in the U.S. Army in Europe. These young men also distinguished themselves in the Military Intelligence Service in the Pacific, where it was recognized that they shortened the war by at least a year. It mattered not at all to the government that the lives of three generations of Japanese Americans suffered insuperable stigma and damage because of a governmental policy based solely on racial bias.

The World War II forced internment of Japanese Americans was the greatest abrogation of constitutional rights of American citizens in the history of this nation. It was driven by governmental policies that raised profound constitutional questions. For Japanese Americans, victimized by greed and racial prejudice, the experience was devastating. It was a dishonoring of the entire population of Japanese Americans, manifested in the shame and sense of guilt at being made prisoners of their own country, branded as traitors merely by the government's actions, by its refusal to inform the public that not a single Japanese American was ever accused of any crimes against the nation.

For the Nisei (the first generation born in this country), the shame of this dishonor was particularly difficult to assimilate. The wound of that experience drove the only generation that could have perhaps given meaning to the experience into a profound silence. For forty years, they not only refused to talk about the camps, they could not talk about them, not even to their own children. They could not explain to their children how the government could take away their freedom and dignity, how they were forced to live in guilt. They held the pain within themselves and lived with the devastating shame of being dishonored in their own country.

I was a little boy at the time, just turning three years old when we entered the gates at Manzanar, in the high desert Owens Valley in California. I grew up in an American prison for no reason except that I was of Japanese ancestry. At the age of three, I was innocent. I had committed no crimes, and I was no threat to the security of the United States. Yet, like every internee at the ten internment camps, I was told I would be shot if I tried to escape.

I can still remember my days at Manzanar, partly because we, the kids of the camps, talked about the experience in the postwar years, but mostly because so many of the memories have stayed with me through the years. It was the seminal event in our lives. For me, personally, it has always defined my life. Even now, some sixty years later, I still have days when some fragment of thought about my experience during the war or its consequence crosses my mind at some point during the day. I recall a moment, or the desert wind that swept through the camp, or the fears or joys I experienced, or the loneliness of being so far from the America that was my home. The images have stayed with me somehow over the years. And among them all, the images of barbed wire and guard towers are etched in my

memory—reminders of who we were and of our place in America those many years ago.

As a result of my experience during the internment, I grew up understanding one fundamental thing, and it formed a basis of my life. Not being white in America meant that I would forever be vulnerable to the prejudices and biases of others, so long as I allowed that to happen. I spent my most formative years growing up behind barbed-wire fences. I knew then—as I stood at the barbed wire looking out on the landscape outside, which I understood to be America—that life would never be the same for me as it was for those who lived somewhere, way out there, outside the confines of those fences.

This book, however, is not about my story. It is a story about America, about a moment in our historical past that should never be forgotten. Hopefully, as a nation, we can learn from our past. More than anything, this is a story about the lives of the 110,000 Japanese Americans who experienced those years behind barbed-wire fences.

We who were the victims of the internment will never be able to tell what that experience was like. The words are there, but the *kimochi*, the feeling, can never be expressed in words. There are no words to tell how bewildered or how scared we were as we stepped from trains and army trucks to view the desolate land around us, enclosed by barbed-wire fences and rows upon rows of barracks. There are no words to tell how empty we felt as we thought of the homes we left behind and the friends we would never see again. Or how lonely the nights were. Or the anguish we felt to realize that our own country had forsaken us. Or the dismay to realize that our place in this country could be so tenuous and rendered so meaningless.

We cannot tell you the damage done to our souls at the sight of the future facing us in those desolate desert surroundings.

And thus, "a picture is worth a thousand words."

MAPS

Ronald Beckwith, an archeologist with the National Park Services's Western Archeological and Conservation Center, originally created the contemporary site maps. They were included in *Confinement and Ethnicity: An Overview of World War II Japanese American Relocation Sites*, published by the NPS in 1999. The maps appearing in this book are based on these earlier versions and were designed by Cong Zhang.

Date of first arrival 5-27-42
Peak population 18,789
Date of peak population 12-25-44
Date of last departure 3-20-46

California

RELOCATION CENTER BOUNDARY

FWS

PRIVATE

FWS

SISKIYOU COUNTY
MODOC COUNTY

TULE LAKE
NATIONAL
WILDLIFE
RUFUGE

Relocation Center Boundary

PRIVATE

Railroad
Ditch

FWS

FWS

Railroad

PRIVATE

NPS

PRIVATE

BLM

FWS
BLM

PRIVATE

PRIVATE
FWS

Ditch

PRIVATE

Ditch

139

B.O.R.
and
Caltrans

Ditch

Relocation Center Boundary

Airport

Ditch

BLM

PRIVATE

TULE LAKE
RELOCATION CENTER
Land Status As Of February 2001

N

0 1 KILOMETER
0 0.5 MILES

MANZANAR
RELOCATION CENTER

Manzanar Howard Rd.

Airport

Fields

Shepherd Creek

NPS Boundary

Fields

Relocation Center
Hospital
Cemetery

Reservoir

Historical Marker

MP Compound

Fields

Chicken Farm

Disposal Pits

Landfill

Bairs Creek

Hog Farm

George Creek

Sewage Disposal

Pipe Line

Los Angeles Aqueduct

Fields

Fields

Fields

Fields

Relocation Center Boundary

395

N

0 1 KILOMETER
0 0.5 MILES

California

Date of first arrival	3-21-42
Peak population	10,046
Date of peak population	9-22-42
Date of last departure	11-21-45

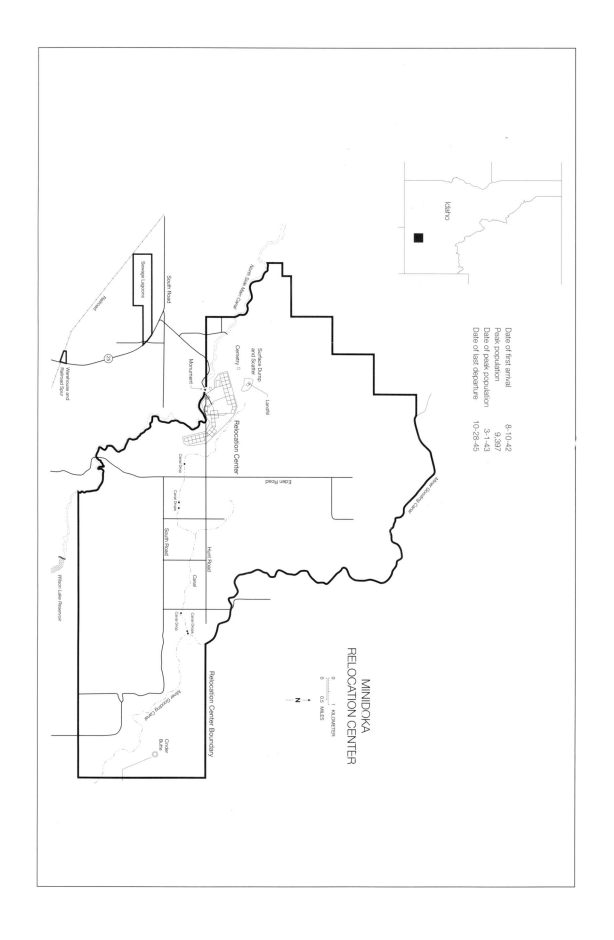

MINIDOKA
RELOCATION CENTER

N →

0 1 KILOMETER
0 0.5 MILES

Date of first arrival 8-10-42
Peak population 9,397
Date of peak population 3-1-43
Date of last departure 10-28-45

Idaho

Relocation Center Boundary

Wilson Lake Reservoir

Minor Gooding Canal

Cinder Butte

South Road

Hunt Road

Canal

Canal Drops

Canal Drop

Eden Road

Minor Gooding Canal

Relocation Center

North Side Main Canal

Surface Dump
and Scatter

Cemetery

Landfill

Monument

Canal Drop

Canal Drops

South Road

Sewage Lagoons

Railroad

Warehouse and
Railroad Spur

25

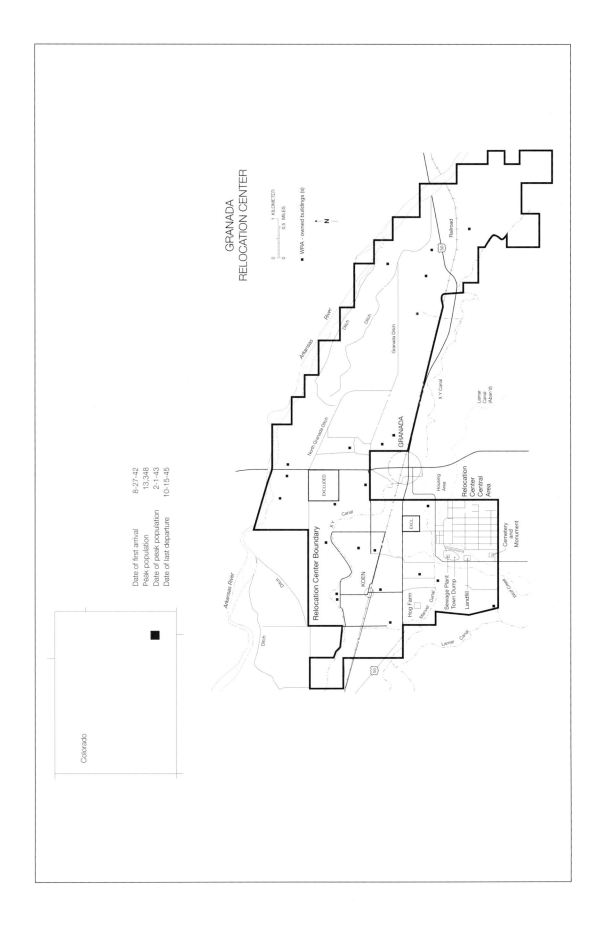

GRANADA
RELOCATION CENTER

0 1 KILOMETER
0 0.5 MILES

■ WRA - owned buildings (s)

N

Date of first arrival 8-27-42
Peak population 13,348
Date of peak population 2-1-43
Date of last departure 10-15-45

Colorado

Relocation Center Boundary

Arkansas River

Ditch

Arkansas River

River

Ditch

Ditch

North Granada Ditch

Granada Ditch

X Y Canal

Lamar Canal (Aban'd)

GRANADA

EXCLUDED

X Y Canal

EXCL

KOEN

Hog Farm

Manvel Canal

Sewage Plant
Town Dump

Landfill

Housing Area

Relocation Center Central Area

Cemetery and Monument

Wolf Creek

Lamar Canal

50

50

Railroad

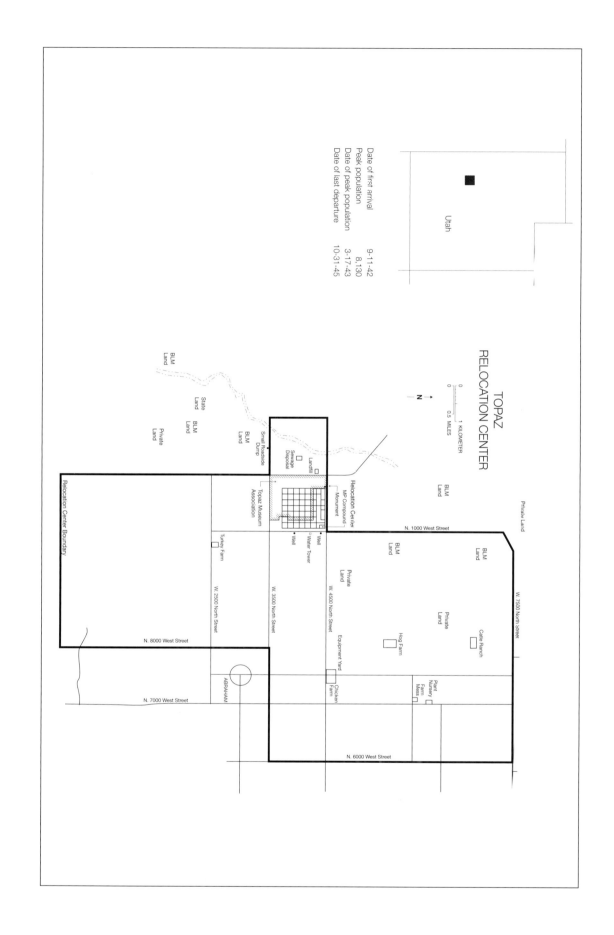

Date of first arrival 9-11-42
Peak population 8,130
Date of peak population 3-17-43
Date of last departure 10-31-45

Utah

TOPAZ
RELOCATION CENTER

HEART MOUNTAIN
RELOCATION CENTER

N

0 1 KILOMETER
0 0.5 MILES

Relocation Center Boundary

Heart Mountain Canal

Garland Canal

Eaglenest Creek

Road Nineteen

Hog Farm

Chicken Farm

Hospital

Monument

Relocation Center

Reservoir

Cemetery

Buck Creek

Iron Creek

Heart Mountain Canal

Garland Canal

Shoshone River

Water Plant

Sewage Disposal

Historical Marker

Pumping Station

Railroad

Dry Gulch

Corbett Dam

Wyoming

Date of first arrival	8-12-42
Peak population	10,767
Date of peak population	1-1-43
Date of last departure	11-10-45

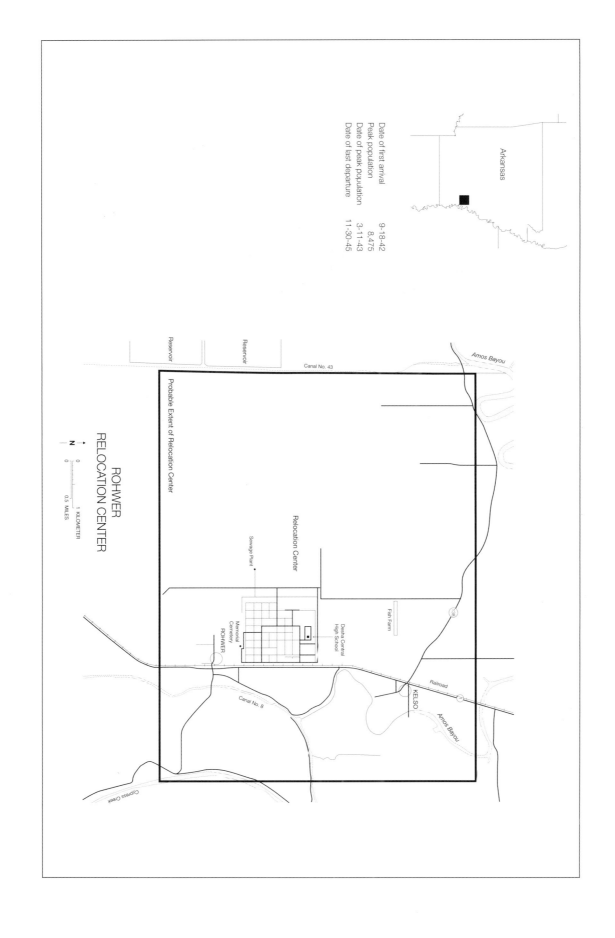

ROHWER
RELOCATION CENTER

Probable Extent of Relocation Center

Arkansas

Date of first arrival	9-18-42
Peak population	8,475
Date of peak population	3-11-43
Date of last departure	11-30-45

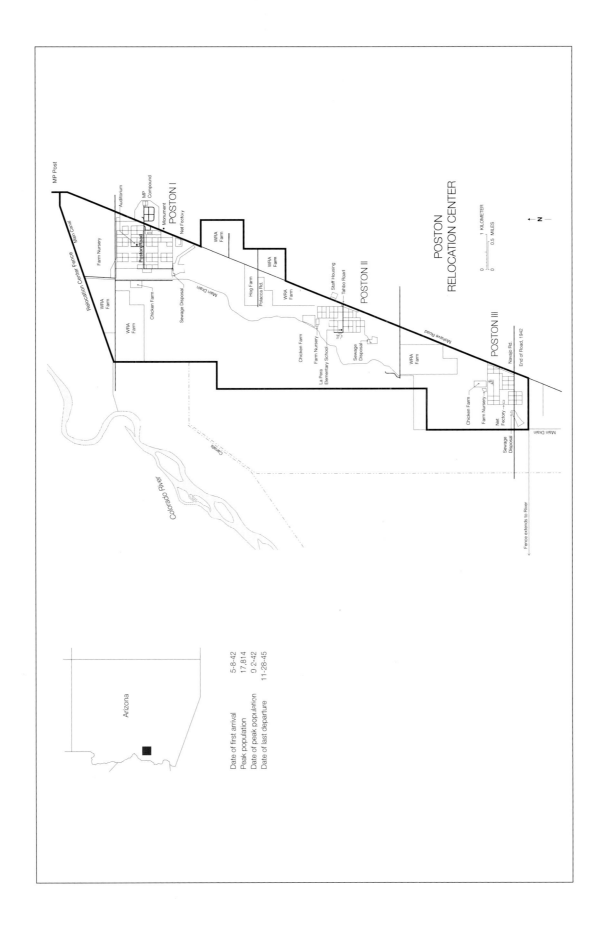

POSTON RELOCATION CENTER

Arizona

Date of first arrival	5-8-42
Peak population	17,814
Date of peak population	0 2-42
Date of last departure	11-28-45

MP Post

POSTON I

Auditorium

MP Compound

Monument

Net Factory

Relocation Center Fence

Main Canal

Farm Nursery

Poston Road

WRA Farm

WRA Farm

Chicken Farm

Sewage Disposal

Main Drain

WRA Farm

WRA Farm

Hog Farm

Polacca Rd.

WRA Farm

Staff Housing

Tahbo Road

POSTON II

Chicken Farm

Farm Nursery

La Pera Elementary School

Sewage Disposal

WRA Farm

Mohave Road

POSTON III

Navajo Rd.

End of Road, 1942

Chicken Farm

Farm Nursery

Net Factory

Sewage Disposal

Main Drain

Fence extends to River

Colorado River

Canal

Main Drain

POSTON
RELOCATION CENTER

0 1 KILOMETER

0 0.5 MILES

N

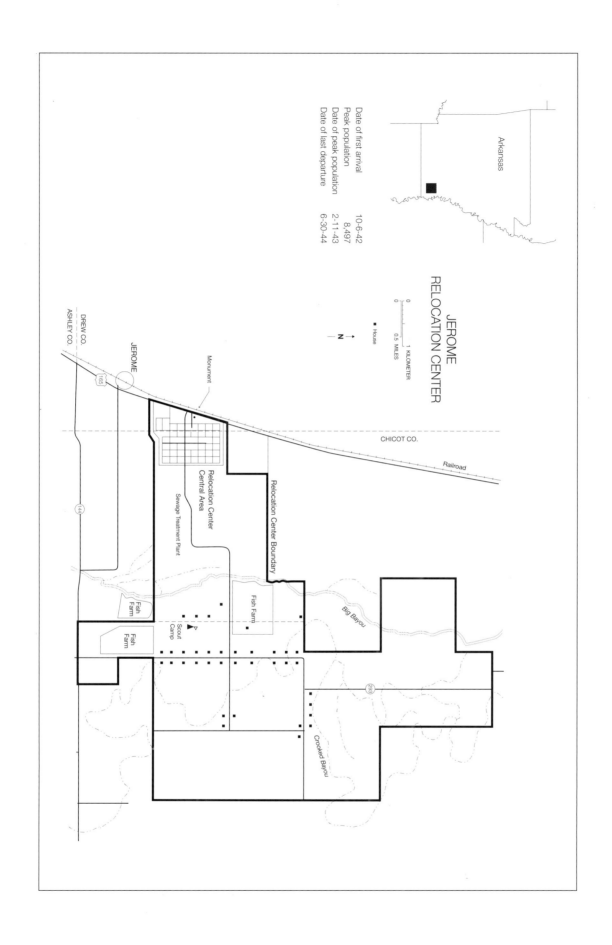

JEROME
RELOCATION CENTER

Date of first arrival	10-6-42
Peak population	8,497
Date of peak population	2-11-43
Date of last departure	6-30-44

0 0.5 MILES
0 1 KILOMETER

■ House

N →

Arkansas

DREW CO.
ASHLEY CO.

JEROME

165

144

230

Monument

Relocation Center
Central Area

Sewage Treatment Plant

Relocation Center Boundary

CHICOT CO.

Railroad

Fish Farm

Fish Farm

Fish Farm

Scout Camp

Big Bayou

Crooked Bayou

Relocation Center Boundary

Casa Blanca Road

CASA BLANCA

Gila River Indian
Reservation Cultural Center

Casa Blanca Canal

Chicken Farm

Hog Farm

Dairy

Sewage Disposal

Landfill

Monument

Butte Camp

MP Post 2

Indian Route 9

Monument

Seed Farm Road

Monument

Canal Camp

MP Post 1

Sewage Disposal

South Side Canal

Dike

Gila River
Indian Reservation

Indian Res. Bdy.

Rest Area

GILA RIVER
RELOCATION CENTER

0 1 KILOMETER
0 0.5 MILES

N

■ WRA building

Arizona

Date of first arrival	7-20-42
Peak population	13,348
Date of peak population	12-30-42
Date of last departure	11-10-45

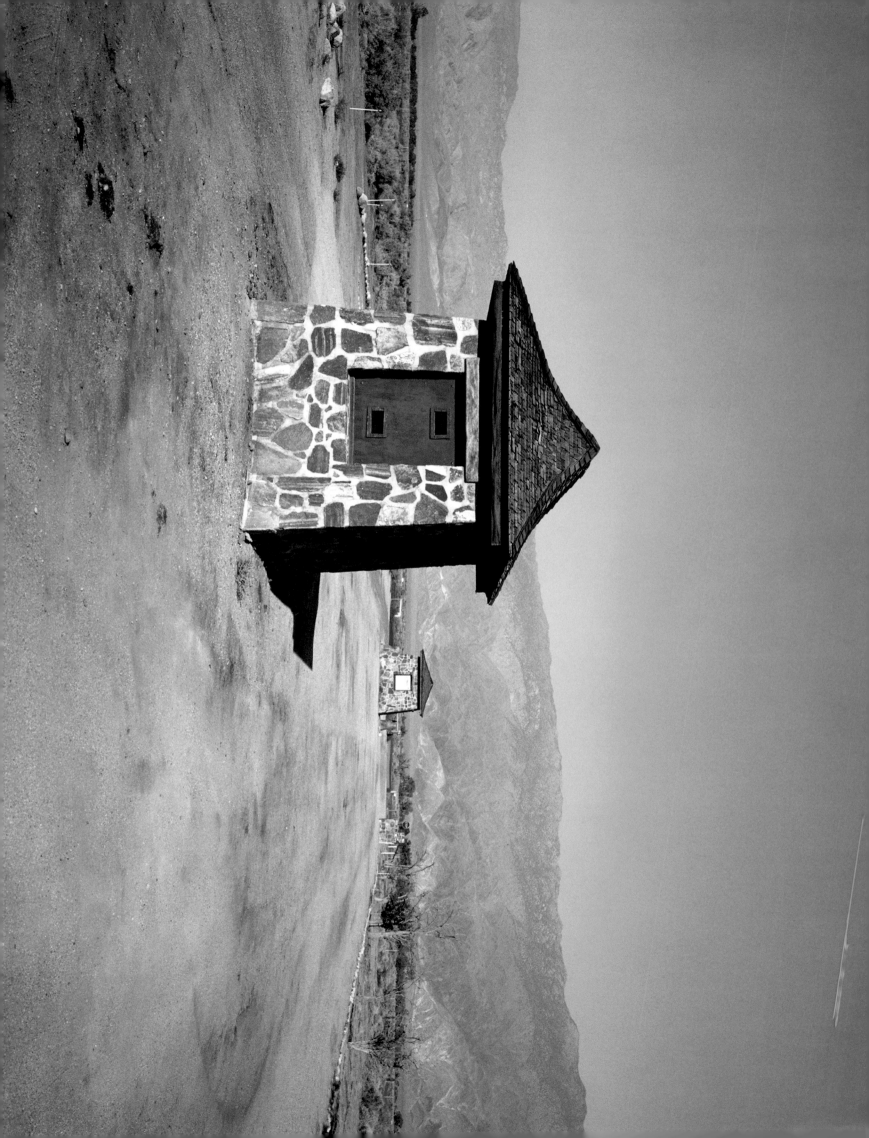

ACKNOWLEDGMENTS

I began making the photographs for this book nearly ten years ago. During this time many individuals have offered their assistance, support, and advice. Without their contributions the completion of this project would have been unimaginable.

A significant body of the work was created while I was a graduate student at Indiana University. The critical framework for this project was developed there during extended conversations with faculty and colleagues. The guidance of Jeffrey Wolin and James Nakagawa was invaluable and I will always be thankful for their insight as I attempted to define the project.

The book was completed while I was working as a professor in the School of Art at the University of Oklahoma. The administration, faculty, and students of the university have been wonderfully supportive. In particular, I need to thank my colleague Andrew Strout for his advice and encouragement throughout the project. Also from the university I need to acknowledge Byron Price, director of the Charles M. Russell Center for the Study of Art of the American West and director of the University of Oklahoma Press. Without the commitment of Byron and the Russell Center the publication of this work would not have been possible. In

addition, I am grateful to the Office of the Vice President for Research and the Research Council for funding support related to the project. Also, I would like to thank Charles Rankin, Matt Bokovoy, Eric H. Anderson, Karen Hayes-Thumann, Cong Zhang, and the staff members at OU Press for their great efforts in bringing this book to fruition.

The writings of John Tateishi, Natasha Egan, and Karen Leong have greatly enhanced this work. Their essays provide a necessary context for understanding both the Japanese American internment and the contemporary photographs of these sites. The significance of their contributions cannot be overstated, and their commitment to the project has been deeply appreciated.

Many other individuals contributed indirectly to this book—too many, in fact, to name them all. They include John and Shirley Penny, who took my entire family into their home when our truck broke down as I was photographing at the Rohwer Relocation Center in Arkansas; Elaine Blackwater of the Gila River Indian Community, who secured permission for me to photograph the internment site located on their tribal lands; and John Ellington, who spent an afternoon walking with me around his family farm, the former location of the Jerome internment site. I interviewed several former internees during the project. Their participation was an especially important part of my preparation for fieldwork. Perhaps more than anything else, it was their stories that compelled me to undertake this project.

Finally, I need to thank my family—my parents, whose unconditional love has been constant throughout my life; my wife, Jennifer, absolutely the most patient individual I have ever known; and our twins, Ethan and Lily, who put everything in perspective. It is their support that makes everything possible.

TODD STEWART

Detail of BARRACKS, TULE LAKE RELOCATION CENTER, 2001
Photograph by Todd Stewart (see page 41)

CONTRIBUTORS

TODD STEWART is an artist and educator living in Norman, Oklahoma. Originally from the Midwest, Stewart began his career as a photographer working for advertising and design clients in Columbus, Ohio, and Atlanta, Georgia. In 2004 he received a Master of Fine Arts degree from Indiana University. Since that time, he has been an assistant professor of photography and digital imaging at the University of Oklahoma. For many years Stewart's concerns as an artist have centered on the relationships between history, myth, and culture. This work has included a growing exploration of the American landscape and a continued examination of the question: Does place hold memory? Stewart's photographs have been exhibited widely throughout the United States and are included in a number of private and public collections.

Detail of INTERIOR OF HOSPITAL MESS HALL, HEART MOUNTAIN RELOCATION CENTER, 2000
Photograph by Todd Stewart (see page 49)

Natasha Egan

Natasha Egan is associate director and curator of the Museum of Contemporary Photography, Columbia College, Chicago. Egan has organized dozens of international and national exhibitions for artists such as Anne and Bernard Blume, Sophie Calle, Seydou Keïta, Katarzyna Kozyra, Nikki S. Lee, and Zwelethu Mthethwa. Her larger thematic exhibitions and essays have included *Alienation and Assimilation: Contemporary Images and Installations from the Republic of Korea*; *Andrea Robbins and Max Becher: The Transportation of Place*; *Manufactured Self*, focusing on how we identify ourselves through what we consume; *Made in China*, focusing on the global impact of manufacturing in China; and *Loaded Landscapes*, focusing on historically and politically charged places. Egan has contributed essays to such publications as *Shimon Attie: The History of Another* (Twin Palms Publishing); *Descry: Antonia Contro and Maurizio Pellegrin* (Secrist Gallery); *MP3: Kelli Connell, Justin Newhall, and Brian Ulrich* (Aperture); *Beate Gutschow: LS/S* (Aperture); and *Contemporary Magazine's* 2004 special issue on photography. She holds an MA in museum studies and an MFA in fine art photography, and a BA in Asian Studies.

Karen L. Leong

Karen L. Leong, PhD, is an associate professor of women and gender studies and Asian Pacific American studies at Arizona State University. Dr. Leong's scholarship focuses on the intersections of gender, race, and nation with an emphasis on how U.S.-Asian relations have shaped constructions of Asian American identity from the nineteenth century to the present, and policies relating to Asian American communities. Her book, *The China Mystique: Pearl S. Buck, Anna May Wong, Mayling Soong, and the Transformation of American Orientalism* was published by the University of California Press in summer 2005. She is co-coordinator of the Japanese Americans in Arizona Oral History Project, a collaboration between the JACL Arizona Chapter and ASU APAS, and is coediting a book based on the collected oral histories. In addition, she is researching her current book project, "Asian American Masculinities and the United States Film Industry."

John Tateishi

John Tateishi was born in Los Angeles in 1939 and spent World War II in the Manzanar Relocation Camp. As an author, educator, and activist, Mr. Tateishi has spent his life committed to the fight for civil rights. During the 1970s and 1980s, he led the movement that eventually resulted in an official apology from the U.S. government for the World War II interment of Japanese Americans. In 1984 he completed an oral history of interment, entitled *And Justice for All*, which was published by Random House and reissued in 1999 by the University of Washington Press. He served for seven years as the national executive director of the Japanese American Citizens League, the largest and oldest Asian American civil rights organization in the country. He is currently writing a personal history of the Japanese American redress campaign.

Detail of Walkway, Elementary School, Poston Relocation Center, 2000
Photograph by Todd Stewart (see page 51)